Laurie Lee
A Folio

by Jessy Lee

Laurie Lee
A Folio

by Jessy Lee

UNICORN PRESS LTD

BOTTLE PERSON WITH DOG
c. 1936
Ink and wash on paper
268 x 382 mm

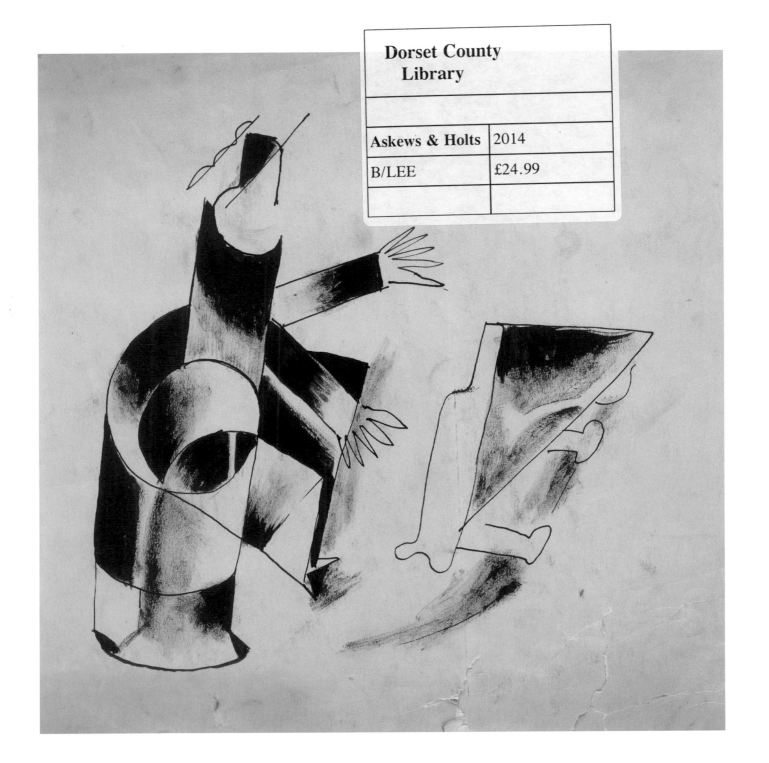

Acknowledgements

My heartfelt thanks to: Jo Crook, Anna Davis, Pamela Dix, Mick Free, Kathy Lee, Graham Peters, Carol Scott, Rodger Williams, Chelsea Arts Club, Unicorn Press.

This book is dedicated to my mother Kathy, with all my love.

Laurie Lee's Published Works

Land at War: The Official Story of British Farming 1939-1944 (1945)

An Obstinate Exile (1951)

A Rose for Winter (1955)

Cider With Rosie (1959) (published in the US as The Edge of Day (1960))

Man Must Move: The Story of Transport (1960)
(published in the US as The Wonderful World of Transportation, (1960))

The Firstborn (1964)

As I Walked Out One Midsummer Morning (1969)

I Can't Stay Long (1975)

Two Women (1983)

A Moment of War (1991)

Red Sky at Sunrise (combined autobiographical trilogy) (1992)

Poetry

The Sun My Monument (1944)

The Bloom of Candles: Verse from a Poet's Year (1947)

My Many-Coated Man (1955)

Pocket Poets (1960)

Selected Poems (1983)

Plays

The Voyage of Magellan for Radio (broadcast 1946; published 1948)

Peasants' Priest (1947)

Films

Malta VC (1945)

Cyprus Is an Island (1946)

A Tale in a Teacup (1947)

Journey into Spring (1957)

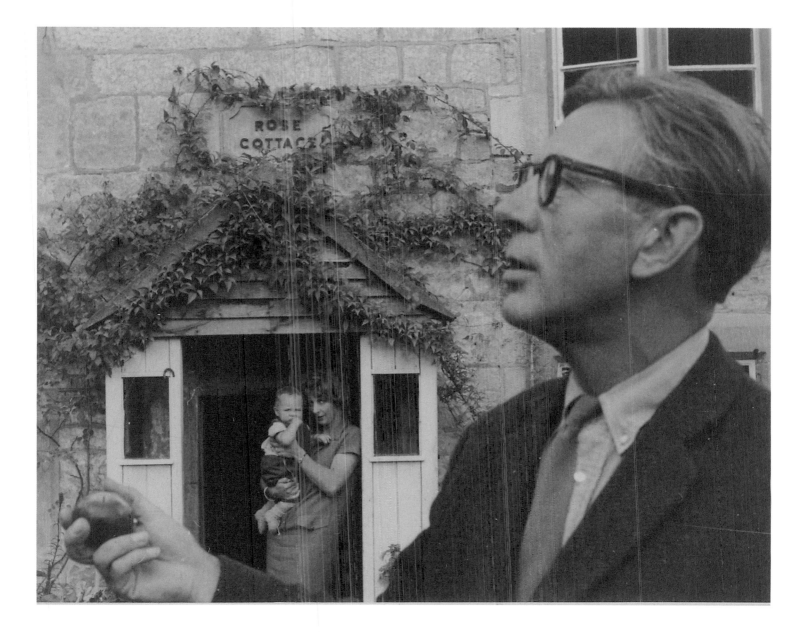

MY MANY-COATED MAN

Under the scarlet-licking leaves,
through bloody thought and bubbly shade,
the padded, spicy tiger moves —
a sheath of swords, a hooded blade.

The turtle on the naked sand
peels to the air his pewter snout
and rubs the sky with slotted shell —
the heart's dismay turned inside out.

The rank red fox goes forth at night
to bite the gosling's downy throat,
then digs his grave with panic claws
to share oblivion with the stoat.

The mottled moth, pinned to a tree,
woos with his wings the bark's disease
and strikes a fungoid, fevered pose
to live forgotten and at ease.

Like these, my many-coated man
shields his hot hunger from the wind,
and, hooded by a smile, commits
his private murder in the mind.

SELF-PORTRAIT
c. 1936
Oil on board
238 X 178 mm

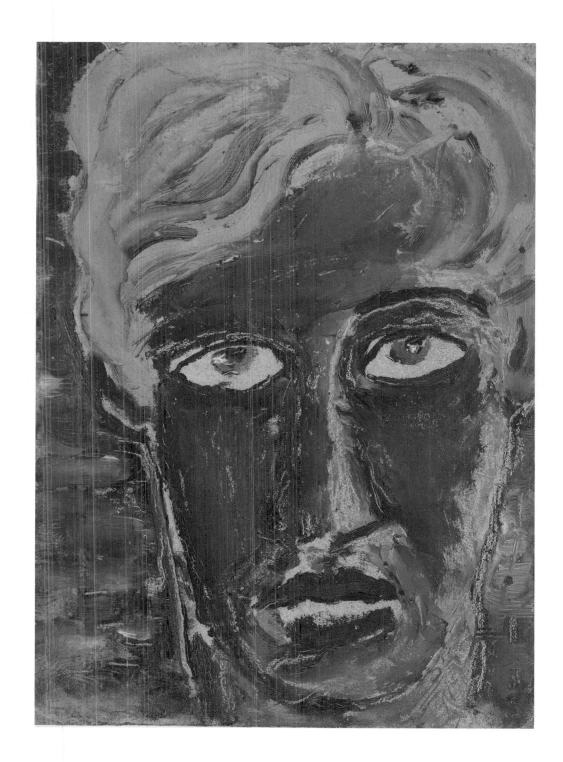

SCHOOL DRAWINGS
c. 1925
Gouache and pencil on paper
274 x 184

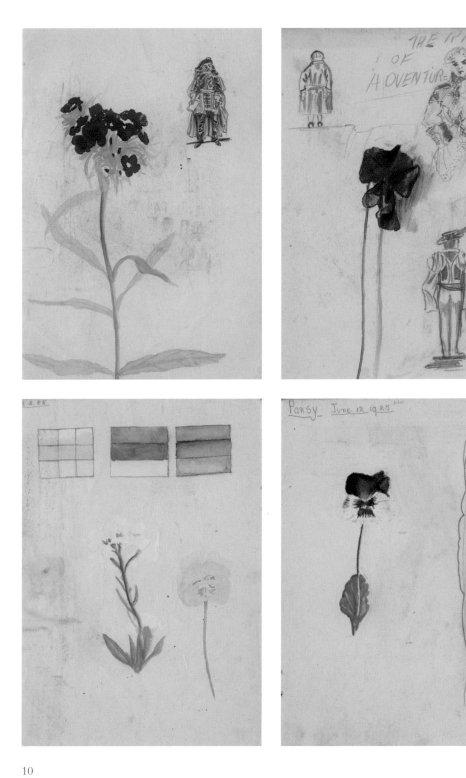

Over the years, many people have enjoyed and studied Laurie's writing. His books have been best sellers, studied in schools and much has been written about him by people who didn't really know him or had never met him. His close friends have loved him, needed his reassurance and feared hurting his feelings. He was a deeply sensitive man. So the purpose of this book is to look at Laurie from a different perspective seeing him through his life as a father and as an artist.

Although Laurie is generally best known for his writing, he had many other gifts. He was a talented musician with a finely tuned ear and a delicate touch. He loved music and had an eclectic taste: as well as his love of the slow movements of Schubert, Mozart and Debussy, he was particularly inspired by the exquisite strings of his dear friend Julian Bream who filled our house, sometimes in person, either with his passionate caress of the Spanish guitar or the ornamental tonality of baroque. Laurie also loved taking part in the poetry and jazz evenings of the early 1960s and was intrigued by the obscure melodies of Eric Dolphy and then soothed by the husky tones of Mose Alison. Laurie was also a very good and prolific photographer.

Along with some of his poems, I want you to see Laurie's art without an analysis so that you can decide how you feel about it. Laurie would have wanted this. He felt strongly that people should feel free to express their own opinion and not be told how to think. I believe that there is a synthesis between Laurie's art and his words which I want to show you along with some of my fondest memories. Although he often suffered for his art and was tormented by ill health, he was great fun as a Dad and I miss him.

ROAD INTO SLAD
c. 1929
Pencil on paper
288 x 400 mm

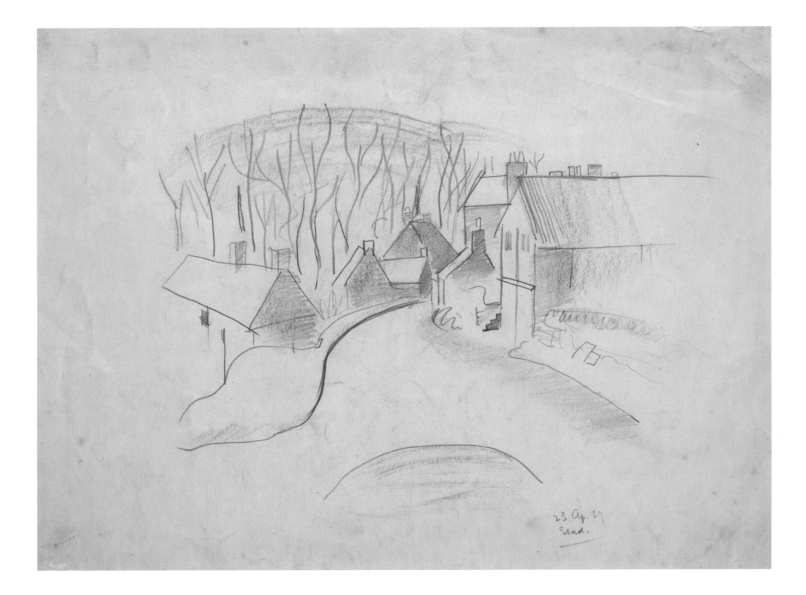

SKETCH OF SLAD
c. 1929
Pencil on paper
254 x 372 mm

SKETCH OF SLAD
c. 1929
Pencil on paper
254 x 372 mm

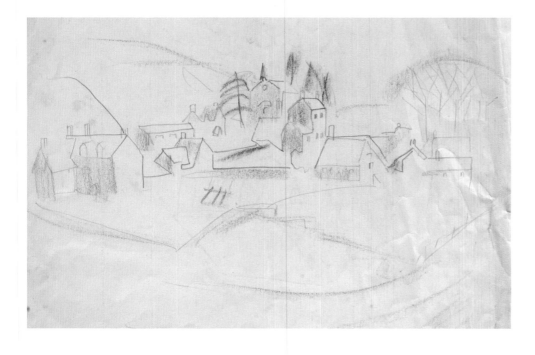

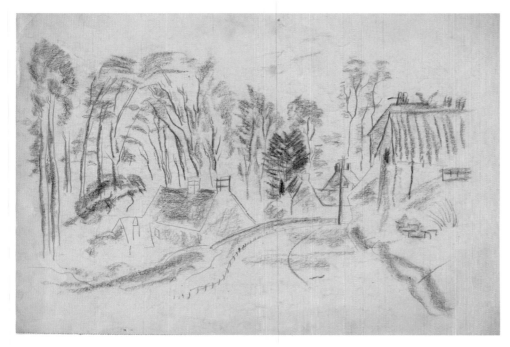

LAURIE AND WILMA
c. 1936
Pencil on paper
252 x 382 mm

Laurie Lee

Wilma Gregory
c. 1936
Ink on paper
276 x 214 mm

In 1961 my parents, Laurie and Kathy Lee, found their ideal cottage in the Gloucestershire village of Slad. Rose Cottage was in the heart of the village, a stone's throw from the local pub, The Woolpack. He was deeply relieved to be living once again in his home village, which he had never truly been able to leave.

In their new home Kathy made elderflower wine and dug in the garden and Laurie watched on from his study. So that he could continue to write while making sure the birds didn't eat the newly seeded lawn, he had one of his eccentric and ingenious ideas.

Quite probably influenced by his time at The Eccentrics Corner during the Festival of Britain in 1951, he made his own bird scarer. By tying some silver milk bottle tops to a long piece of string and drawing it from the lawn up into his study on the first floor, he would give the line a regular twitch which would of course, scare the birds away. He told me later that he had thought about tying it to his pencil – but then, he said, the lawn might never grow.

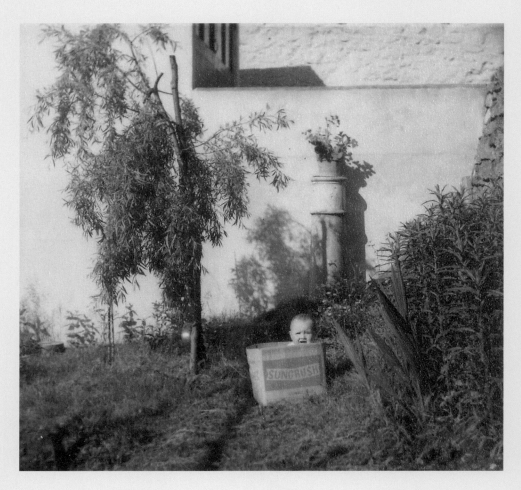

ADVERTISING (BISODOL)
c. 1951
Ink on paper
202 x 163 mm

STILT MEN
c. 1951
Felt pen on paper
202 x 163 mm

No Guns or Butter
c. 1951
Felt pen on paper
202 x 163 mm

JESSY'S HEAD
c. 1969
Ink on paper
202 x 250 mm

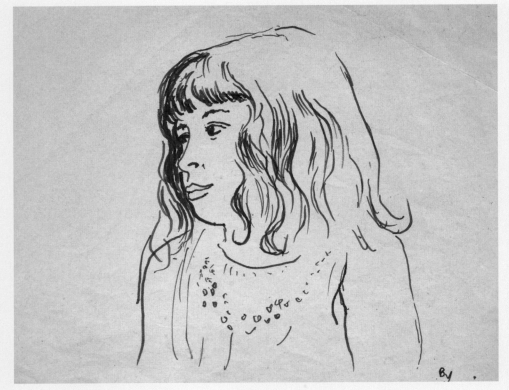

Jessy Lee, aged 7, writing in Vogue
in 1970 about her parents Cathy and
Laurie Lee:

*My mummy is clever and makes lots
and lots of wine and drinks it and she
also digs hard in the garden. My daddy
is more clever than mummy. He doesn't
dig in the garden. He writes books and
looks after us all. My mummy has long
fair hair, blue eyes, pink cheeks and
drives the car. I love her. Daddy has a
light brown face, silver hair, a proper
nose and a red mark on his cheek, quite
a small one. When I was little he was
a pirate and used to dive under the sea
for treasure but never got any. Today he
doesn't go under the sea anymore, but he
drinks whiskey and talks to people and
plays the violin and guitar. He's often
ill or lazy. I wouldn't choose any other
mummy or daddy. They shout a lot and
mummy's got a very loud voice and dad's
got a very soft voice and they shout at me
and at each other. One day perhaps he'll
find that treasure and make us all rich
as devils so the police will be cross at us.
I call mummy Moonbeam because she's
beautiful and daddy Diddy-Boy because
he's big. If they ever tried to get divorced
I'd tie them up with big thick ropes. If
they died, I'd die too – or I'd probably
faint anyway.*

Laurie Lee

JESSY IN BOX
1964
Photograph

JESSY IN BOX
1964
Photograph

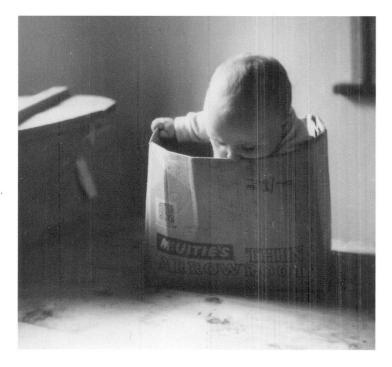

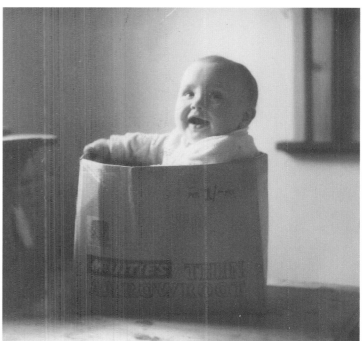

JESSY AND PICASSO
c. 1965
Photograph

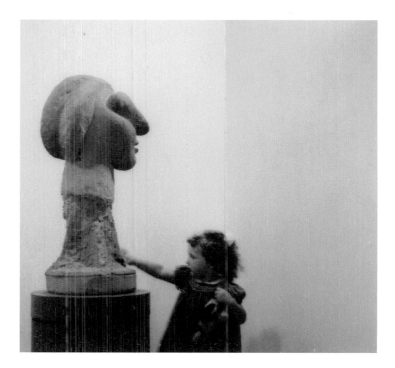

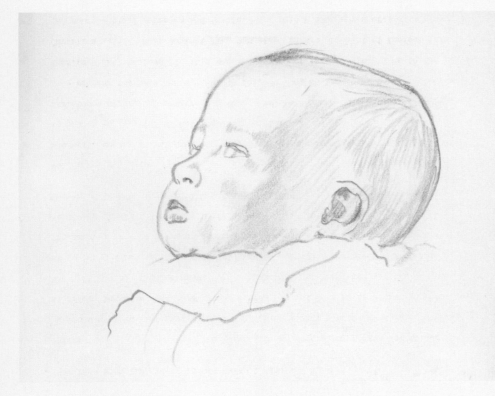

I was born on 30th September 1963.

A year later *The Firstborn* was published. It is a touching book, a lyrical and emotional essay about the joys, fears and expectations he experienced of becoming a father later in life, illustrated by Dad's early photographs of Mum and me.

When I was in my early twenties, Laurie told me that I was not in fact his firstborn and that I had an older sister. I was more concerned with his distress in telling me than I was upset by the fact itself. Although I was confused, I was also excited to have an older sister after years of being the only child. I wish I had known sooner but Laurie feared that it might come between us.

They had been married for 12 years and Kathy still had no child. Laurie recounts in his book *Two Women* "But one morning I walked into the kitchen and found Kathy perched up on the window-sill. She looked at me transfigured, her eyes full of confusion and triumph. 'Oh Lol!' she said, 'would you believe it?… I'm pregnant.' and she slipped into my arms and wept." Laurie was overjoyed. He later said 'Suddenly there was Jessy… a late miracle born to my roots. It was almost as though my return to Slad was not only to revisit my childhood, but also to find Jessy.'

From a distance, Yasmin was kind to me and always sent a birthday card. We would meet only very occasionally as our lives were so different. It was too late for a deeper relationship to evolve but I still have very fond memories of her. Sadly, Yasmin died in 2009.

Laurie Lee

KATHY AND JESSY
1963
Crayon on paper
386 x 285 mm

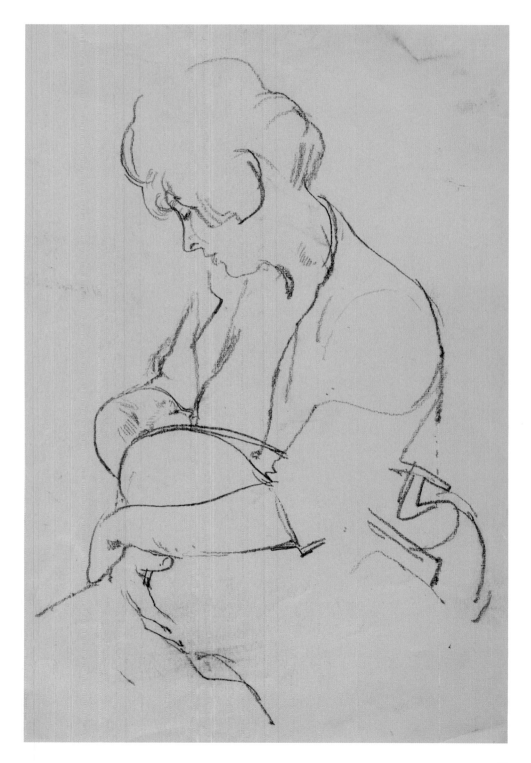

LANDSCAPE, SOUTHERN SPAIN
c. 1952
Ink and pastel on paper
277 x 215 mm

RECLINING NUDE
c. 1937
Gouache on paper
206 x 291 mm

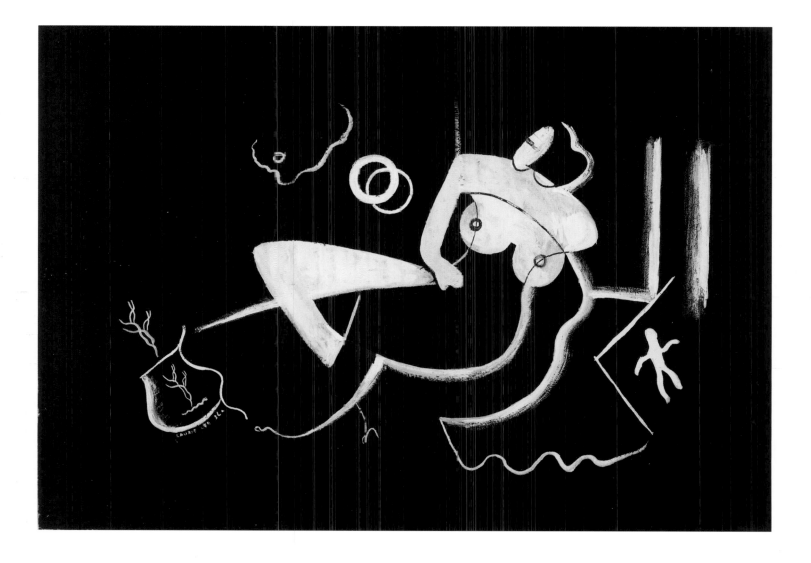

GUITARIST AND SINGERS
c. 1937
Gouache on paper
488 x 323 mm

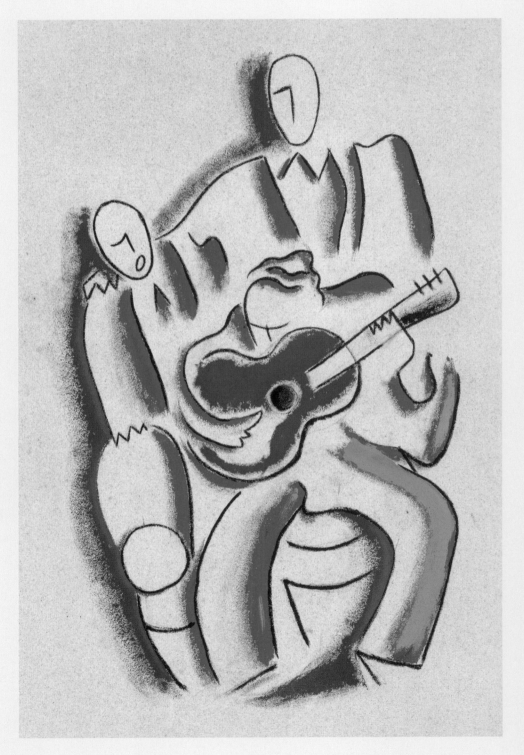

Dad finished *As I Walked Out One Midsummer Morning*, which was published in 1969 as a sequel to *Cider with Rosie*. It too enjoyed enormous acclaim and success. For years this book has inspired many young adventurers to follow in his footsteps across Spain.

I developed a love for Spain when I was a small child. My earliest memories are of being in a dilapidated hotel in a port in southern Spain; mosquito and cockroach infested, but full of warmth, Flamenco and rabbit stew. The Spanish seemed to love Mum and Dad. Mum, blonde and beautiful had been taught to dance Flamenco by the famous Rialito in Seville. She would dance with the locals who were impressed with her natural rhythm and mastery of the castanets. Dad, even in his broken Spanish, would make them laugh and share their sympathies and they both would sing their own Spanish duet, 'Lorenzo and Katalina'. Dad captures the magic of their time together in Spain in his book, *A Rose For Winter*.

MUSIC IN A SPANISH TOWN

In the street I take my stand
with my fiddle like a gun against my shoulder,
and the hot strings under my trigger hand
shooting an old dance at the evening walls.

Each saltwhite house is a numbered tomb
each silent window crossed with blood;
my notes explode everywhere like bombs
when I should whisper in fear of the dead.

So my fingers falter, and run in the sun
like the limbs of a bird that is slain,
as my music searches the street in vain.

Suddenly there is a quick flutter of feet
and children crowd about me,
listening with sores and infected ears,
watching with lovely eyes and vacant lips.

Cordoba, 1936

Although Dad loved Rose Cottage, he always craved the privacy and the view from the house next door. By coincidence the house came on the market just as he had made enough money to buy it.

His success also meant that I was able to have the horse that I had always longed for. We had gone to a local auction where amongst various animals on parade, we spotted 'Red'. He was a bedraggled but beautiful chestnut horse who I barely recognised from having once ridden him in an indoor riding school years before. Dad bought Red for next to nothing, to save him from the abattoir.

Mum, who had no experience with horses, looked after Red while I was at school. It was fortunate that he was gentle in the stable because we discovered rather too late that the reason that this horse was for sale was that he was notoriously difficult to catch and when caught, he was very dangerous to ride. He would rear in traffic and wouldn't stop until he wanted to. A number of people thought they might get the better of him; all failed, and eventually I was the only person who could ride him.

Dad was very fond of our horse. The only time I saw him cry was on the terrible day that Red became aged and incurably ill; he had to be put down. Dad would occasionally come home having rescued some forlorn animal; I remember two enormous, manic Friesian bullocks and a couple of neurotic goats all sharing the field with poor old Red beneath the house.

Of course we did have many funny times. From those days a recurring vision is that of Dad in the field wearing one of Mum's long skirts. Red seemed to associate trousers with being ridden which he didn't like much. Dad had the bright idea of wearing the skirt to help me to catch him. After

STEANBRIDGE HOUSE, SLAD
c. 1943
Oil on board
226 x 303 mm

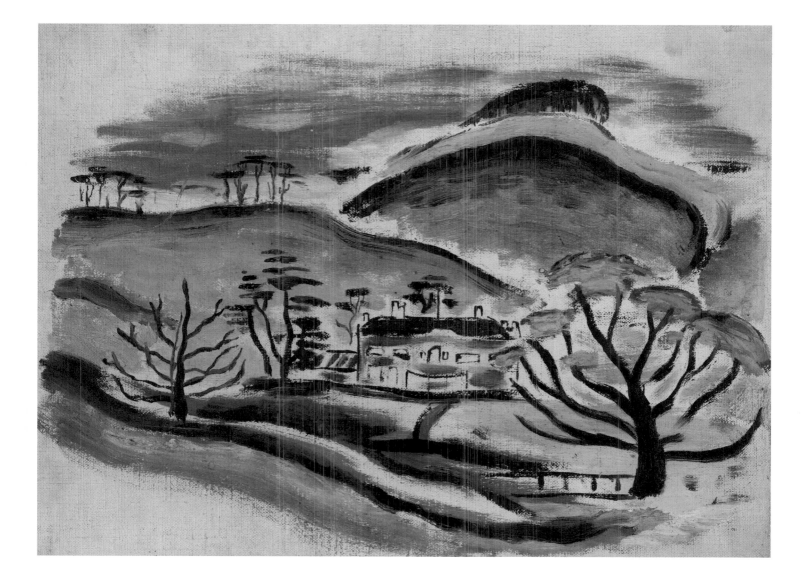

VIEW OF SLAD
c. 1929
Pencil on paper
255 x 372 mm

Laurie Lee

STUDENT DRAWING
Date unknown
Pencil on paper
374 x 254 mm

JESSY AND RED
c. 1989
Photograph

JESSY AND RED
c. 1989
Photograph

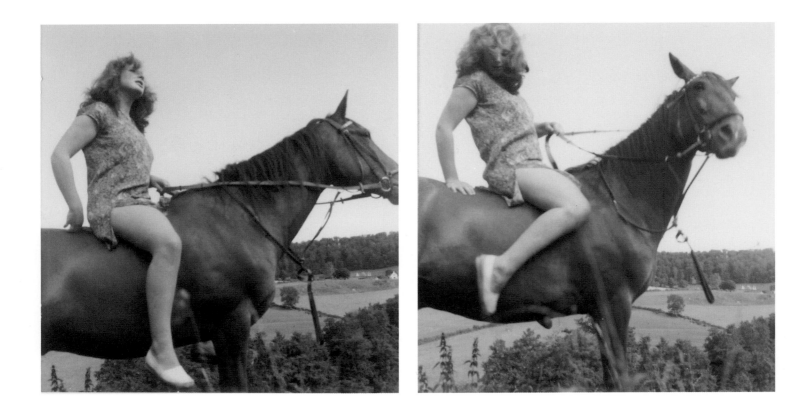

SUGAR ISLAND DANCER
c. 1940
Gouache on paper
260 x 166 mm

that, I was known to ride in a dress from time to time. The neighbours were quite amused.

We all became deeply attached to Red and he lived with us for 17 years or so. Looking back, he had come to represent something solid for us all to turn to. A distraction and companion we all needed to enable us to cope with the more difficult times in our triangulate relationship.

Apart from my joy of riding, I would also love to dance. Whilst it was mostly a solitary occupation, I felt that it would entertain Dad, who often seemed quite wistful but it was more difficult for him to watch than I knew.

"And watching her dancing there in that brief and questioning solitude of her body, I felt all the sad enchantment of seeing something about to take wing. That as soon as the limbs were tested and proved, the will found to be strong enough, she would be risen and away and gone from me at last, leaving behind the dropped dolls, the circling goldfish, the empty hamster cage, and the horse in the field with its turned raised head." *Two Women.*

Also on the success of *As I Walked Out One Midsummer Morning*, Dad was able to send me to boarding school which I didn't like much, to say the least.

LAURIE, KATHY AND JESSY
1964
Photograph

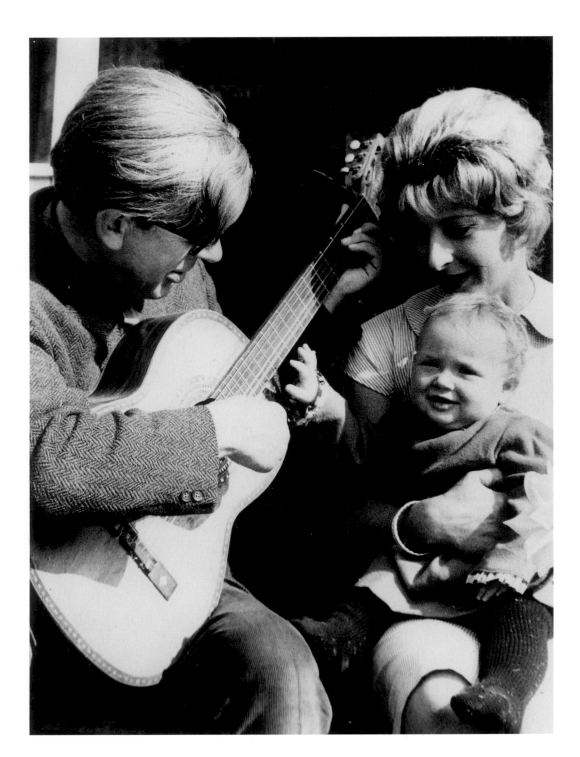

Later on, Dad told me that he had made the mistake of listening to the advice of a friend when wondering how best to protect me from the trials of the world. He increasingly had to leave Mum and I while he worked in London and travelled abroad. In fact, he was quite specific in his fantasy of what he wanted for me as described so emphatically in *The Firstborn*: to stay at home with him.

"I would like to give her the sort (of education) that matches her curiosity and needs, and not one to make her life a misery. I'll not send her away if I can help it; she's bound to leave soon enough. I hope she'll stay at home, inky fingers and all, and be around where I can watch her grow." *The Firstborn*.

"I've no mind to pack her off to some boarding-school, to lose sight of her for months at a time, only to get her back, stiff as a hockey post, and sicklied o'er with the pale thought of caste.
...No I hope she'll be content to get her conformity at a day school and to unravel it back at home each night."
The Firstborn.

Like so many other girls at boarding school I fear I wasted too much time wondering why I had been sent away and wanting to get home. In hindsight, I wish I could have been able to focus

more on some of his other words:

"There is so much I want to show and give her; and also much I would protect her from. I would spare her the burden of too many ambitions, and too many expectations, such as the assumption that simply because she is mine she must therefore be both beautiful and clever. I'll try not to improve her too much, or use her in games of one-uppance, or send her climbing too many competitive beanstalks; and I'd like to protect her from the need to go one better than her parents in order to improve their status by proxy." *The Firstborn*.

I was too young when I first read *The Firstborn* to understand the complexities of being a parent: the dreams, hopes and promises for a child juxtaposed with the realities that emerge over time when promises sometimes just have to be broken.

"For the rest, may she be my own salvation, for any man's child is his second chance. In this role I see her leading me back to my beginning, re opening rooms I'd locked and forgotten…" *The Firstborn*

I can now see the beauty and depth of Dad's words, which would be contemplative and aspiring for any new parent, but even as a small child I felt that my position in life was to look

WOMAN, GREEN
c. 1937
Gouache on paper
508 x 379 mm

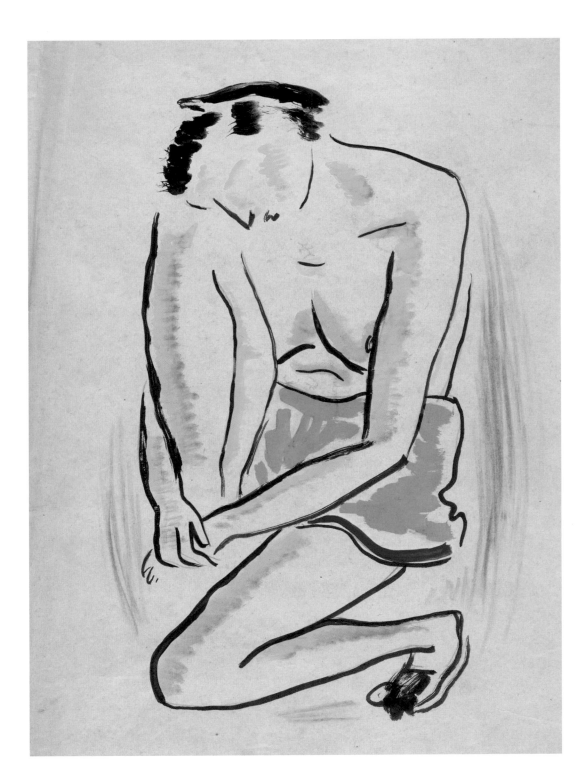

SUGAR ISLAND ODALISQUE
c. 1940
Gouache on paper
442 x 509 mm

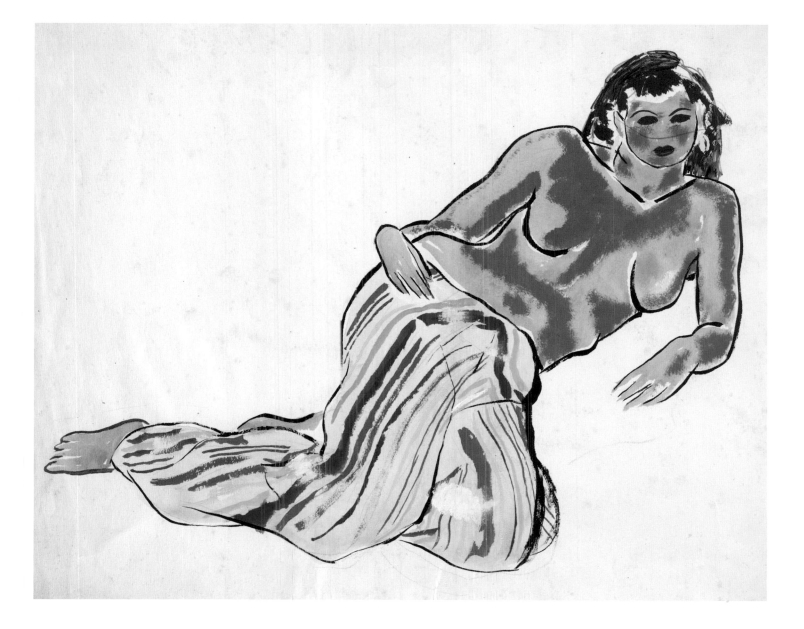

NUDE FIGURE
c. 1940
Ink on paper
325 x 502 mm

after my parents – often the mission of the only child. I came to understand that Dad was also trying to protect me from his struggle with his illness.

In spite of the success of this book, he was depressed, quite possibly due to the great quantities of medication he had to take for his epilepsy and bad lungs. He valued life but had to live it through a veil of insecurity because of epilepsy – an affliction of which he was deeply ashamed. I only learnt at the end of his days how terrified he was about having a seizure in public and losing his dignity. I discovered through reading his diaries how Dad would go to any lengths to conceal his illness from me. When an attack was imminent, he would take a strong sedative after I had left for day school and just about managed to get washed, shaved and dressed before I came home; and of course I was none the wiser. He would have kept this secret had I not discovered that the children with epilepsy whom I cared for at the time took the very same tablets.

It would seem that I was to make a number of discoveries about Dad in my early twenties. He liked his Pale Ale and whiskey toddies and a good wine was always appreciated. He wasn't the archetypal bad tempered drinker; Dad became much more cosy and often very funny when he had had a drink.

NUDE FIGURE
c. 1940
Ink and gouache on paper
325 x 502 mm

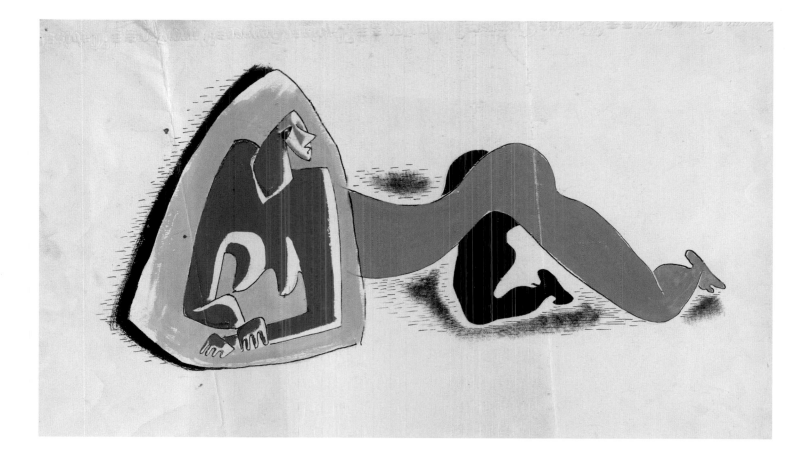

KATHY, PROFILE
c. 1950
Gouache on paper
379 x 253 mm

SELF-PORTRAIT, PROFILE
c. 1950
Gouache on paper
379 x 255 mm

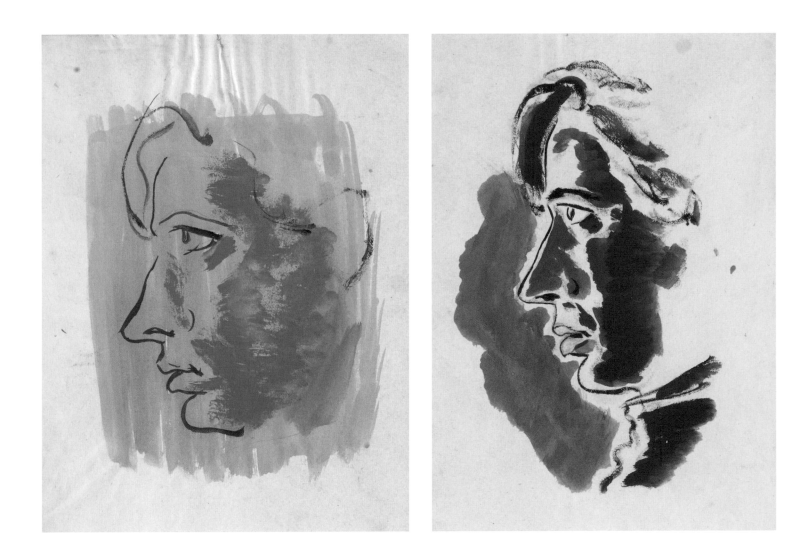

FIRST LOVE

That was her beginning, an apparition
of rose in the unbreathed airs of his love,
her heart revealed by the wash of summer
sprung from her childhood's shallow stream.

Then it was that she put up her hair,
inscribed her eyes with a look of grief,
while her limbs grew as curious as coral branches,
her breast full of secrets.

But the boy, confused in his day's desire,
was searching for herons, his fingers bathed
in the green of walnuts, or watching at night
the Great Bear spin from the maypole star.

It was then that he paused in the death of a game,
felt the hook of her hair on his swimming throat,
saw her mouth at large in the dark river
flushed like a salmon.

But he covered his face and hid his joy
in a wild-goose web of false directions,
and hunted the woods for eggs and glow-worms,
for rabbits tasteless as moss.

And she walked in fields where the crocuses
branded her feet, and mares' tails sprang
from the prancing lake, and the salty grasses
surged round her stranded body.

23 Jersey Road Woollahara N.S.W
Australia
28 Dec 1973

Darling Jessey,
 I'm glad you got my
letter because you are such a long
way away and I thought the
post-seagulls would get tired &
drop it out of their beaks. Your
letter, written before the school
holidays, arrived today — so I
think the bird or fish who
brought it went the wrong
direction.
 I'm sorry about your wobbly
tooth & your antibiotics and I
hope you are better. (Have you
ever had unclebiotics? they taste
of Harolds). You must tell me
what was wrong with you when
I see you.
 I hope you had a good
christmas. It is summer here,
very hot, and we had
christmas dinner in the garden.
I drove 2000 miles with
Uncle Jack & saw a lot of
Kangaroos. You would have loved
them. They were all fat, like
daddy, & jumped about
carrying bottles of beer in their
pouches.
 The Koalos

Beer →
beer

drop out of the trees &
fall on your neck like teddy
bears & nibble your ears. You
would like them too. I hope

Christmas 1973

AEROGRAMME
BY AIR MAIL ✳ PAR AVION

MISS JESSY LEE
49 ELM PARK GARDENS
LONDON SW10 9PA
ENGLAND.

COUNTRY OF DESTINATION

SENDER'S NAME AND ADDRESS

Laurie Lee
23 Jersey Rd
Woollahra
NSW
Australia POSTCODE

FOLD FLAPS BEFORE MOISTENING GUM. FOR
MAXIMUM ADHESION. PRESS DOWN FOR A FEW SECONDS

To see you again before long if
God is kind. Be good and
look after mummy. Lots
of love & kisses.
 from your loving Daddy
 X X X X X X X X
I'm glad you saw miss Helen.
love to Hampy & Cherry. Nibble nibble,
chirp, chirp.

SELF-PORTRAIT, LARGE
c. 1936
Gouache on paper
560 x 384 mm

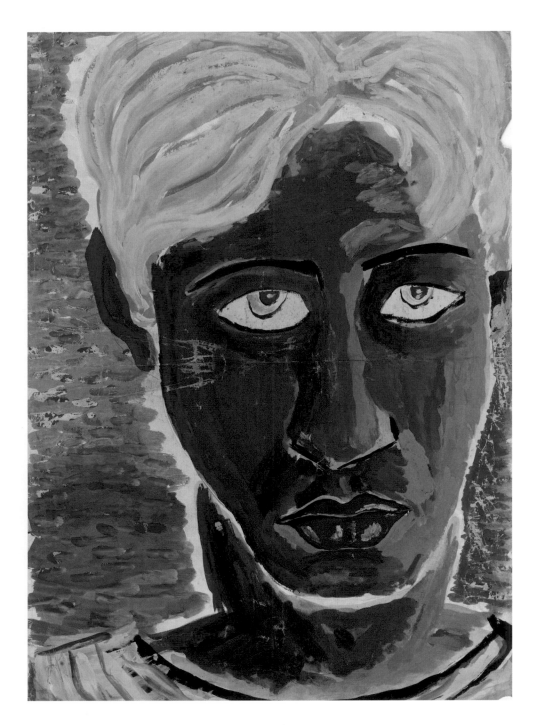

In 1973, when I was nine, he went
to Australia to stay with his older
brother, my Uncle Jack. Jack Lee had
become well known as the director of
the film, *A Town Like Alice*. It seemed
like an eternity but I think he was only
there for about six weeks. He wrote to
me as he always did when one or both
of us were away.

On Dad's return from Australia,
Mum and I went to collect him from
Heathrow Airport. We were very
excited about seeing him again of
course and we waited and waited –
but no Dad. As we were beginning
to worry, a security guard came and
told us to follow him into the Customs
Area. Immediately, we were hit by
the scent of the most pungent perfume
imaginable. After his bags had been
opened and searched, it turned out
that a bottle of aftershave had broken:
thus the suffocating scent. Dad, who
detested flying, had been drinking
whiskey for the whole duration of the
flight and was exhausted as well as
being slightly the worse for wear. It
took two guards and both of us to help
him into the car. I know we shouldn't
have laughed but it was very funny.
To add to that, he had a great white
bandage over his left eye on his coffee
suntanned face where he had been hit
by a flying beer bottle at the Pakistan
versus Australia test in Sydney. He was

NUDE FIGURE WITH GREEN HAIR
c. 1937
Gouache on paper
321 x 517 mm

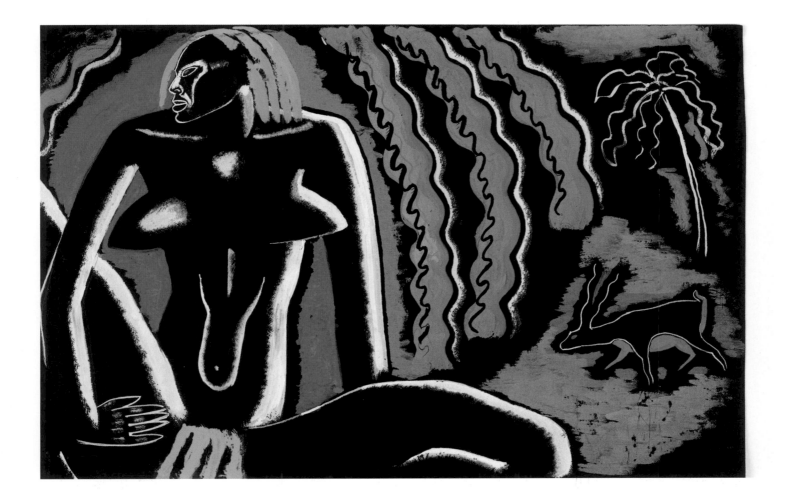

Nude Figure with Baby
c. 1937
Lino print on paper
418 x 533 mm

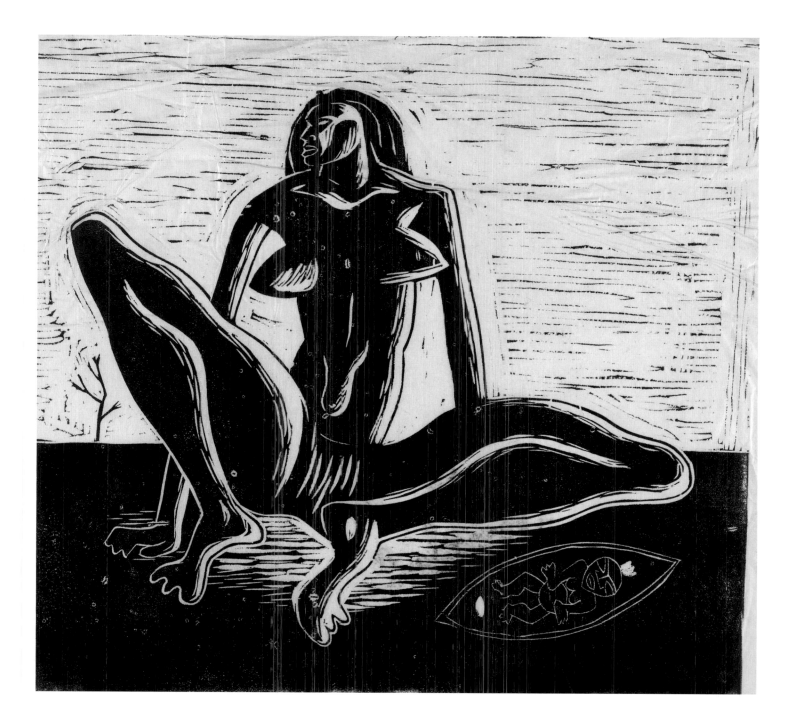

DUCK!
c. 1936
Pencil on paper
228 x 176 mm

CHICKEN!
c. 1936
Ink on paper
287 x 210 mm

LEAF FORMS
c. 1936
Pencil on paper
504 x 378 mm

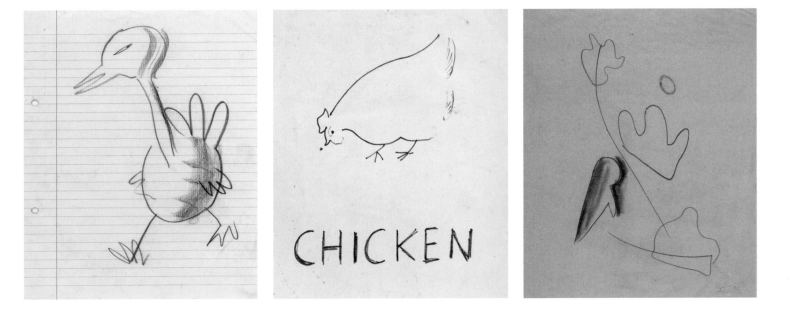

(Above) Arms
Date unknown
Pencil on paper
278 x 382 mm

(Below) Nude
Date unknown
Pencil and ink on paper
278 x 382 mm

also wearing the most garish blue and white striped jacket which he wouldn't have been buried in. He never wore aftershave again.

Dad always enjoyed convivial company and conversation and found it more and more frequently in London. The minor miracle was that Dad managed to get hold of our flat at 49 Elm Park Gardens and he did so by an act of mild deception. He had a friend who worked for the Chelsea Housing Improvement Society – an organisation set up to support poor artists. In order to prove his suitability, Dad turned up for the viewing with a sketchpad and paintbrush in his hand. He couldn't admit he was primarily a writer.

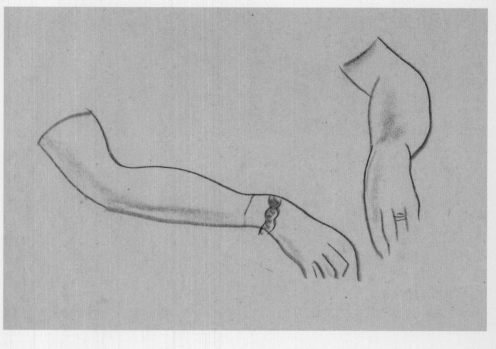

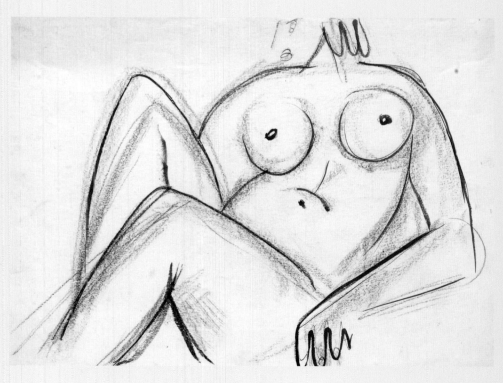

(ABOVE) PERFORMANCE SKETCH
c. 1962
Felt pen on paper
148 x 210 mm

(BELOW) PERFORMANCE SKETCH
c. 1962
Felt pen on paper
148 x 210 mm

PERFORMANCE SKETCH
c. 1962
Felt pen on paper
210 x 148 mm

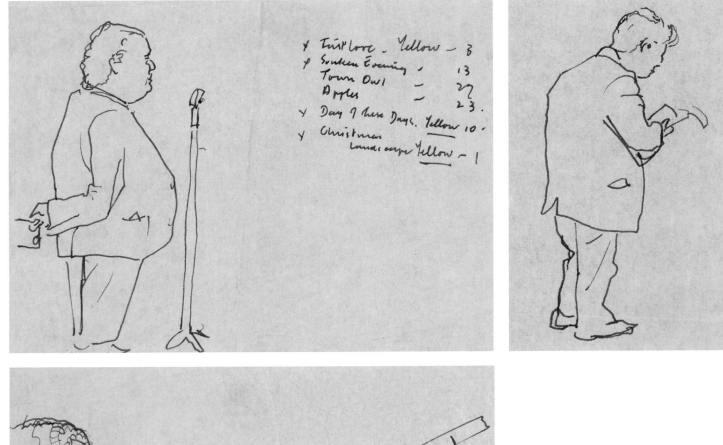

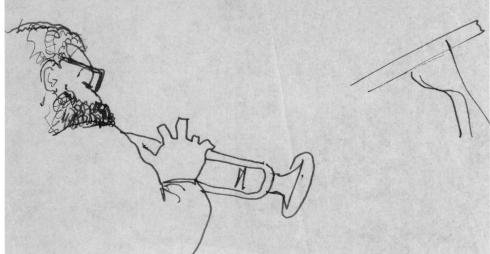

TO MATTHEW SMITH

Fused with the minerals of sun and earth,
spurting with smoke of flowers,
oil is incendiary on your moving brush;
your hands are jets
that crack the landscape's clinker and draw forth
its buried incandescence.

These molten moments brazed in field and flesh
burn out for us,
but you can stand and nail within a frame
the fire we mourn,
can catch the pitchpine hour and keep its flame
pinned at the point of heat.

Our summer's noon you pour into a mould,
a rose its furnace;
through green and blue its burning seeds unfold,
through night and day:
raked by your eyes the paint has never cooled.

Of course we were surrounded by artists, some in person, others on our walls: Sir Matthew Smith, Bill Thomson, Dame Elisabeth Frink, William Scott and Sir Jacob Epstein. There were a number of portraits of Mum and Dad by their dear friend and great painter, Anthony Devas – easily the paintings that I believe captures them both most sensitively. The best of these portraits of Dad is now in the National Portrait Gallery.

Cathleen Mann painted two huge and devastatingly beautiful portraits of Mum, one of which still has tyre marks across it having been run over by a taxi as it flew off the roof of our Morris Traveller in a sudden gust of wind while being transported home from her studio. Dad said of Catherine, "She had no egotism as a painter. She was never satisfied. She had more respect for other artists than herself. But her gift was rare, and she used it for giving. I think that is what she considered her work was for. She knew the dark just as the rest of us do. But if you look around, you will see some of the lights she left burning for us."

Mum was an artist's model in the early days and the most sumptuous is a pencil drawing of her as a four year old by her uncle Sir Jacob Epstein. There is a beautiful and delicate watercolour of her leaving an exotic-looking swimming pool by Edward Ardizzone (I refer to this as her 'Venus' painting) and Sir Hugh Casson would send many a note and cartoon to Mum via Dad if they had been attending a Royal Academy event having had to leave Mum behind to look after me.

Photographers were also dotted about on the walls – mostly in the bathroom and most, surprisingly, still survive. The greatest photographs of Laurie in my eyes were by Bryan Wharton, Bill Brandt, Sandra Lousada and Paul Matthews - our great friend and the son of one of my godfathers, Tom Matthews, editor of *Time* magazine.

KATHY
c. 1959
Pencil on paper
361 x 270 mm

KATHY
c. 1959
Pencil on paper
330 x 202 mm

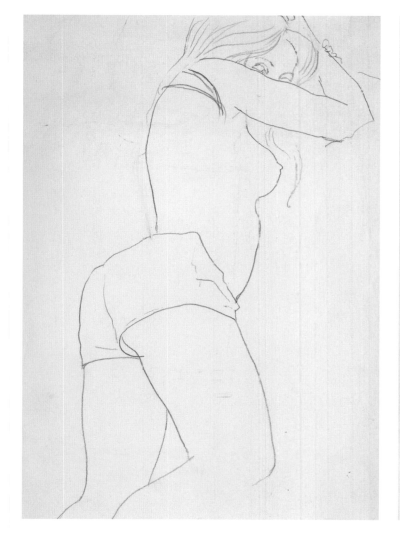

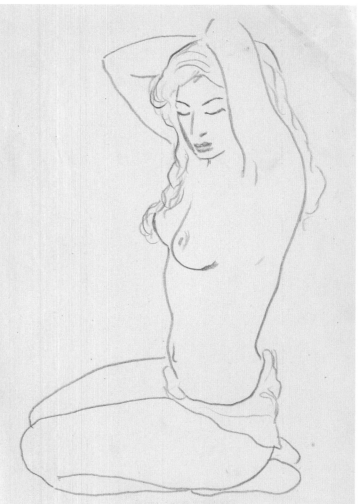

GIRL CROUCHING
c. 1937
Pastel, gouache and ink on paper
254 x 178 mm

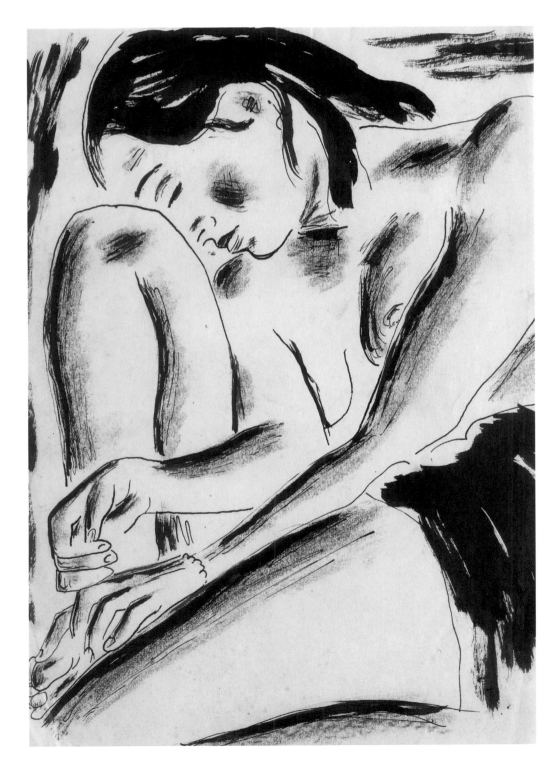

Kneeling Nude
c. 1937
Gouache on Paper
502 x 328 mm

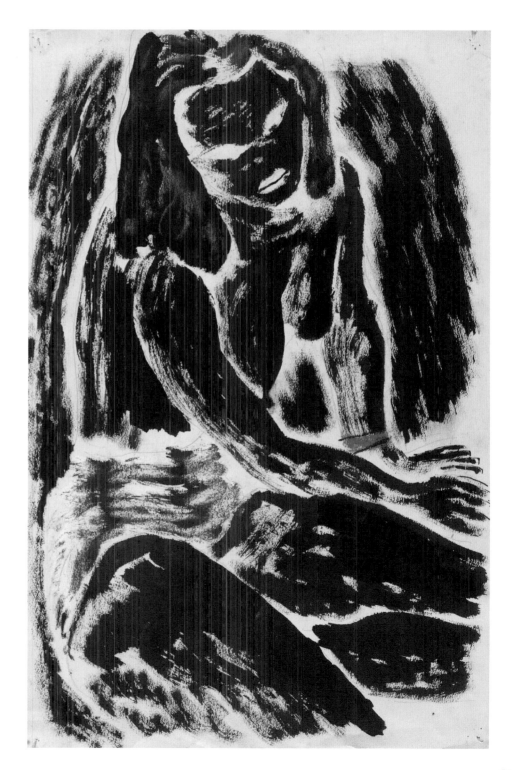

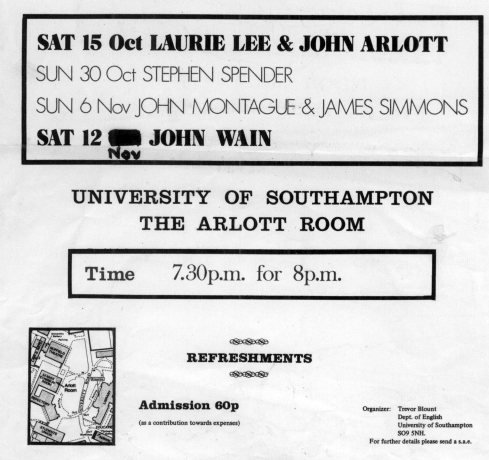

JOHN ARLOTT
1977
Felt pen on paper (reverse of poster)
420 x 297 mm

JOHN ARLOTT
1977
Felt pen on paper (reverse of poster)
420 x 297 mm

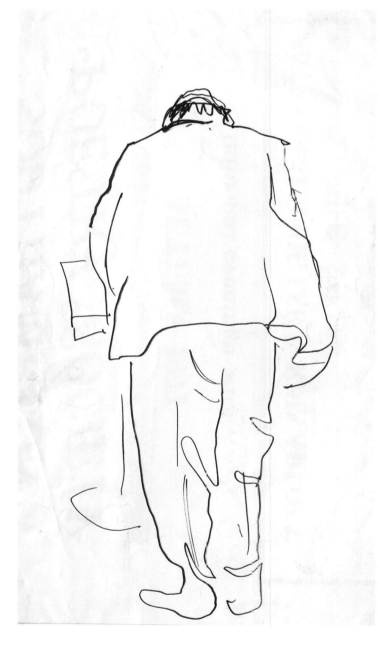

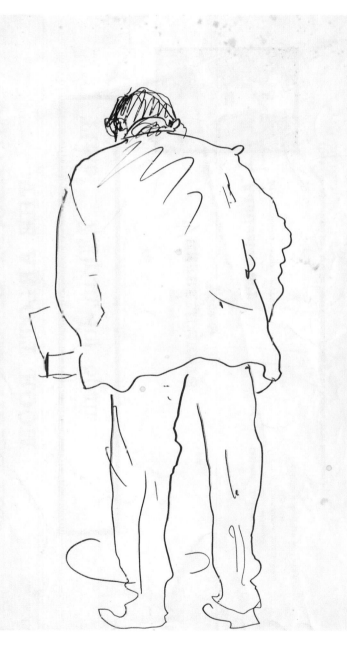

I still have such vivid memories of Chelsea and Elm Park Gardens. The flat was a large maisonette and randomly decorated with the generous cast-offs from one of my godmothers, Jane, the writer Elizabeth Jane Howard. There was the luxuriously opulent but moth-eaten Aubusson carpet in Laurie's bedroom which eccentrically doubled up as the sitting room where Dad would occasionally entertain friends and where our Christmas tree was placed– decorated only in white and tinsel; "none of that vulgar multi-coloured tat" was allowed. There were left over roles of Coles wall paper and Sumptuous Sanderson materials. Jane showed Mum how to decorate and Mum would do it; even wallpapering the down pipes. Never a join could be seen. She would make matching lampshades, curtains and cushions, usually put together in a rush and sometimes left unfinished.

Nevertheless, Mum made a home for us. Although I never knew Jane, I had a lovely relationship with my other godmothers, Antonia Young (Godmum Tony) and the actress Dame Peggy Ashcroft (Peg). My earliest pet companion came from Peg on my fourth birthday - a radiant blue budgie who I promptly named 'Cherry'. None of us knew the rationale for my choice of name but I have always been a bit eccentric. From time to time, Cherry was allowed to fly freely in the flat, chirping.

The only word he would repeat was 'Diddyboy', much to Dad's delight. I will always remember Mum drying out poor Cherry over the gas cooker after she had found me, aged five, in the bathroom giving him a rather deep bath. To this day, only our nearest and dearest know what became of Cherry 35 years later…

CROUCHING WOMAN
c. 1939
Ink and gouache on paper
320 x 265 mm

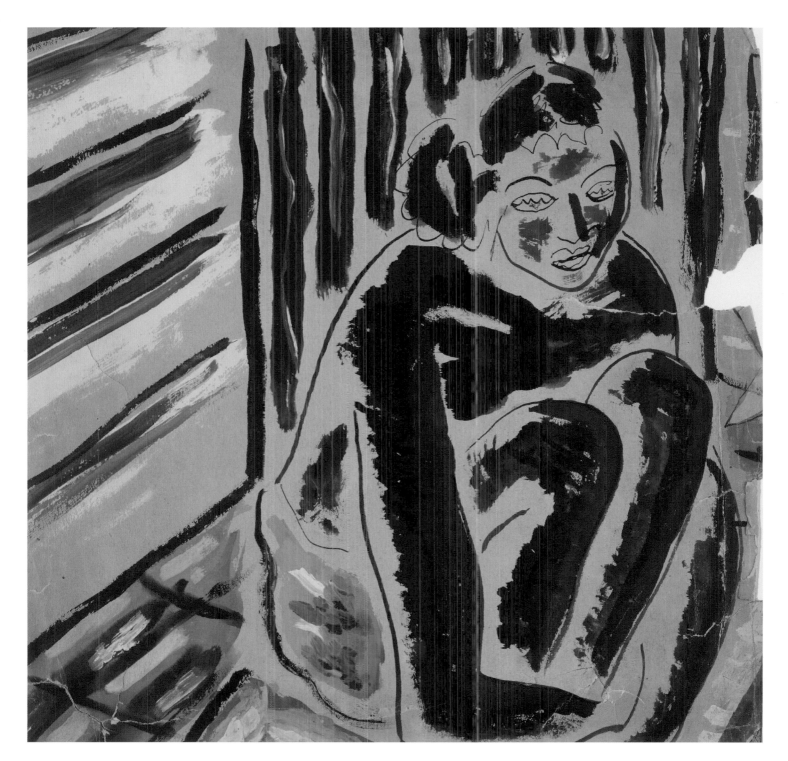

WOMAN WITH JUG
c. 1936
Gouache on paper
388 x 522 mm

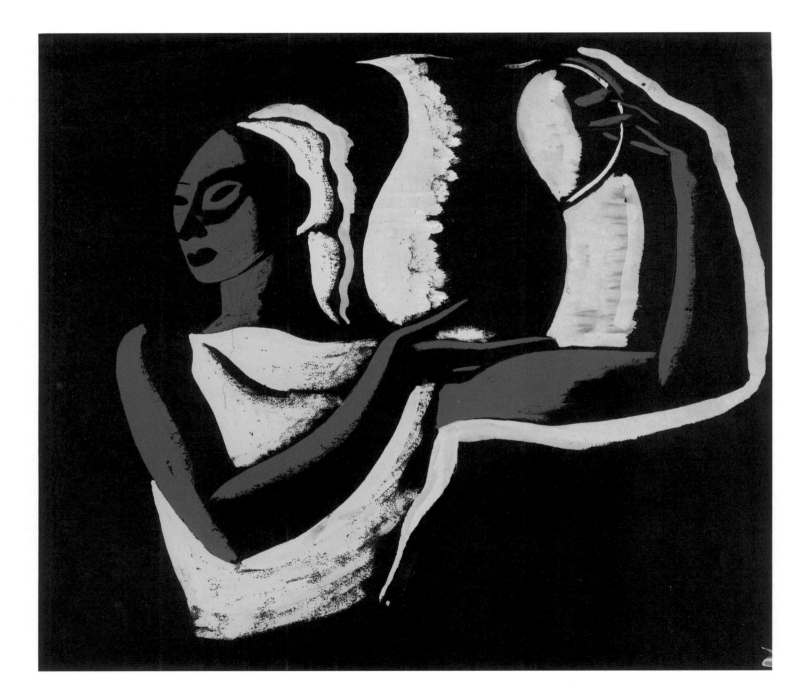

Abstract Face
c. 1936
Paint on board
427 x 312 mm

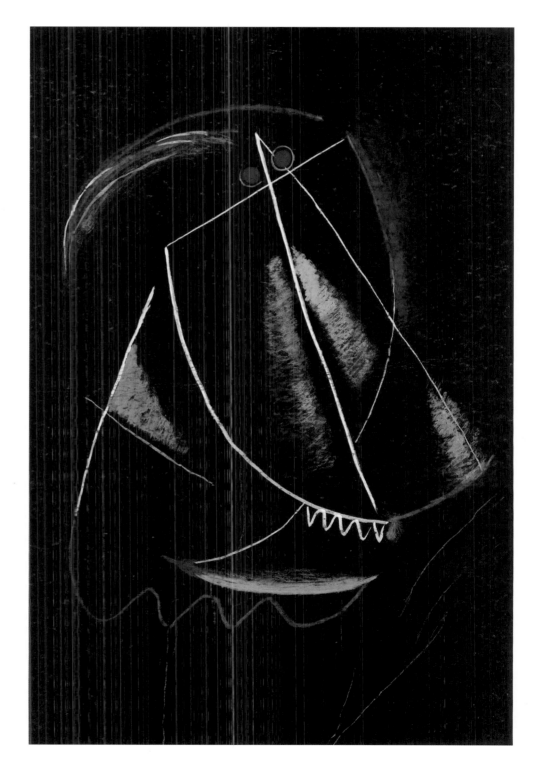

ABSTRACT LANDSCAPE, COLOUR
c. 1939
Ink and pastel on paper
202 x 253 mm

Laurie Lee

ABSTRACT LANDSCAPE
c. 1939
Charcoal on paper
410 x 281 mm

I remember when I first caught sight of the old, grey tattered A2 art folder, which contained the real treasure of Dad's drawings and paintings. It was against the damp wall in his study. I would often try to push past Dad to catch a glimpse of the hidden treasures that I was certain were in that room. Occasionally, on a birthday or when I was unwell, Dad would magic up a Barbie doll from this treasure chest. When I spotted the folder and asked him what it was, "Never you mind! You can have it when I'm dead!" he told me. Always a remark that would put off any further enquiry from me.

I recall being about 10 years old and would relish rare moments inside this secret room. Dad's study was mostly locked and even if he would leave the door ajar, Mum and I would never enter unless invited. We understood and respected his privacy and we all would knock on each others doors before entering. I have never understood how people can barge into other people's lives, unannounced. I still feel the same now. Dad always liked to be prepared because he always wanted to present his best side to the world. To be dressed well and above all, not to appear unwell.

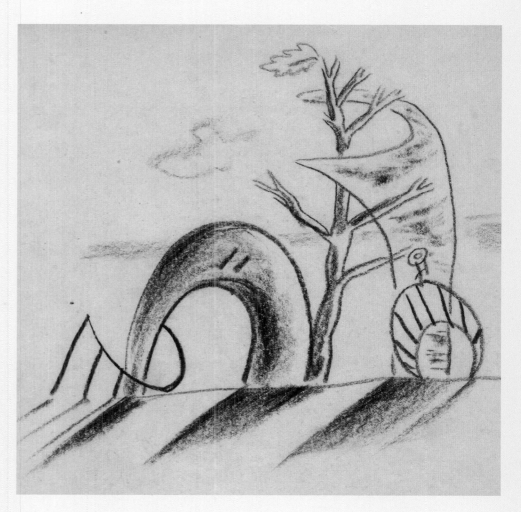

WOMAN SITTING
Date unknown
Gouache and ink on paper
382 x 561 mm

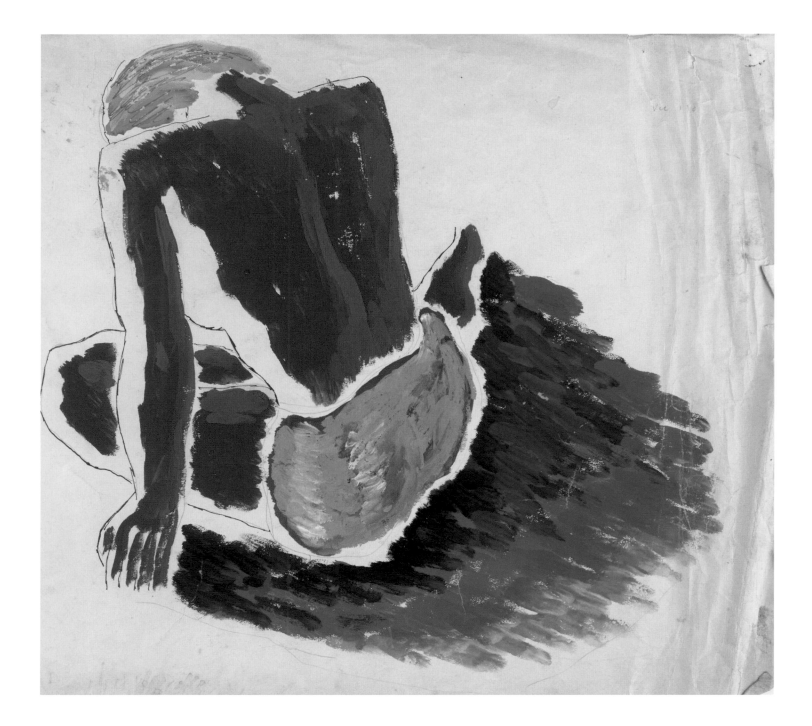

Laurie Lee

STUDENT SITTING
Date unknown
Ink on paper
350 x 270 mm

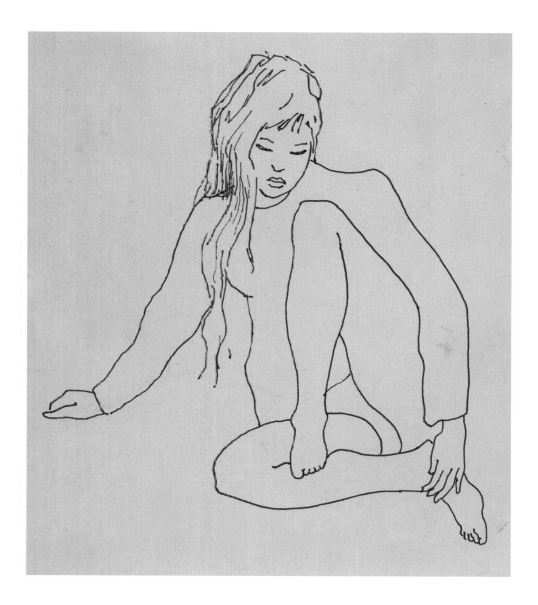

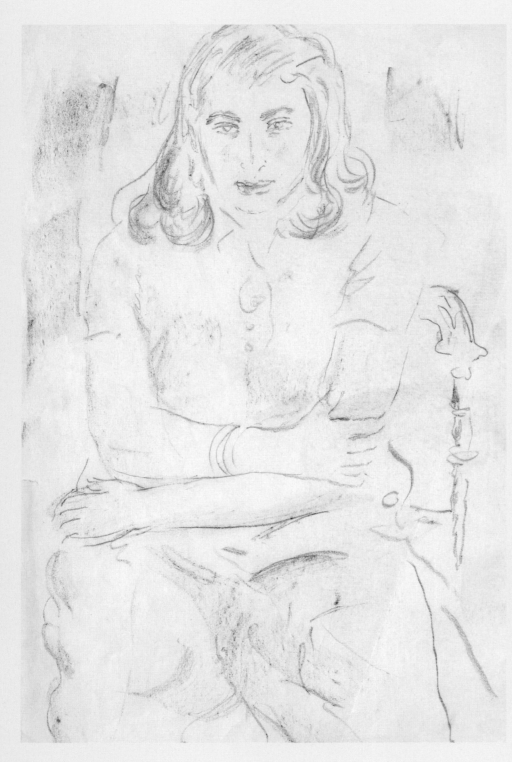

I collected enough information from these stolen visits to create quite a real picture in my mind's eye of his bits and pieces. He took most of these oddments with him wherever we lived. I still have most of them dotted around.

There would be empty bottles of Perequita (he was sometimes paid in wine) with a candle stuffed into the neck (always prepared for the numerous power cuts affecting us all in the 1970s). Here would be odd empty bottles of Double Diamond and Whitbread Pale Ale and old pipe tobacco tins crammed with staples, paper clips, rubber bands and razor blades; there would be pin ups of the Cadbury's Flake girl in flowing dresses – and of Barbara Bach in less. There was Raquel Welsh – and Brigitte Bardot and of course many photographs of his real love, my mother.

He kindly positioned some of my early drawings on the wall facing the door so that I could see them when bringing him a cup of tea. A Viking horn drinking vessel supported Pentel pens, Derwent Water coloured pencils (I always tried to get my hands on those) and 4B pencil stubs, roughly sharpened with his ancient Moroccan flick knife and a wooden six-inch ruler. (Eventually, I found fourteen of these scattered throughout his desk. He

NUDES, LYING
Date unknown
Pencil on paper
203 x 330 mm

RECLINING GIRL WITH FLOWERS
c. 1940
Gouache on paper
379 x 509 mm

Laurie Lee

WOMAN IN PANTS
c. 1938
Pastel on paper
334 x 272 mm

WOMAN IN ARMCHAIR
c. 1936
Gouache on paper
507 x 380 mm

Woman Sitting
c. 1937
Gouache on paper
507 x 380 mm

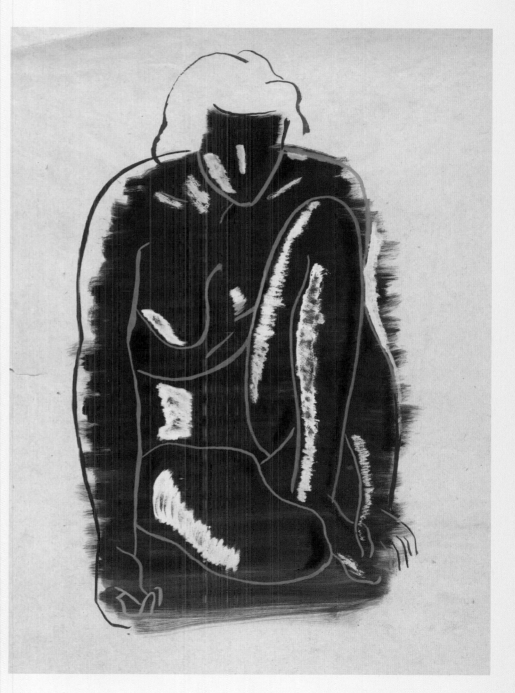

could never find anything.) And his pipe which I managed to get my hands on far too early in life.

Of course there was a mountain of paper; mostly old film and radio scripts; always in pencil. Later on we found all of his original manuscripts – there were many versions of the same thing. He couldn't bear to discard anything, especially his words. I can see reams of sheets repeated with only a word changed in a paragraph – or even a page – painstakingly written out again and again. He could type with his two forefingers but it took him far too long to write that way and pencil was a much softer instrument, enabling the mind to wander more freely, he told me.

When Dad was not feeling unwell he was quite a joker. Like an errant teenager he would love to see Mum and I fall about screaming with laughter or horror, or he would entertain us in any way he could. He was always one to celebrate an occasion. One Halloween Mum and I were having an evening to ourselves carving out grisly potato heads to light up with candles. We were watching Dracula films. It had become quite late and Dad had not come home, so Mum had decided it was time for bed. Just as she was putting out my bedroom light out we heard a strange creaking

VIKING
c. 1924
Pencil on paper
275 x 184 mm

KNIGHT
c. 1924
Pencil on paper
179 x 112 mm

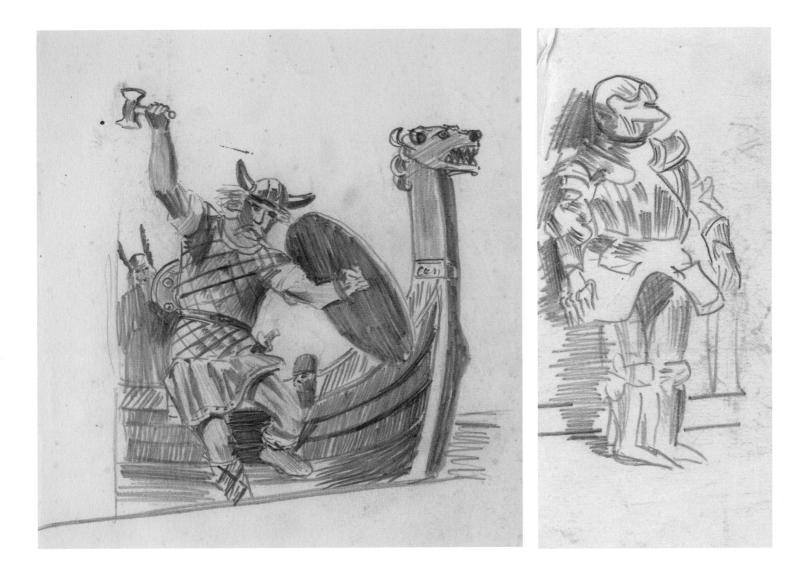

A YOUNG WARRIOR
1927
Pencil on paper
190 x 260 mm

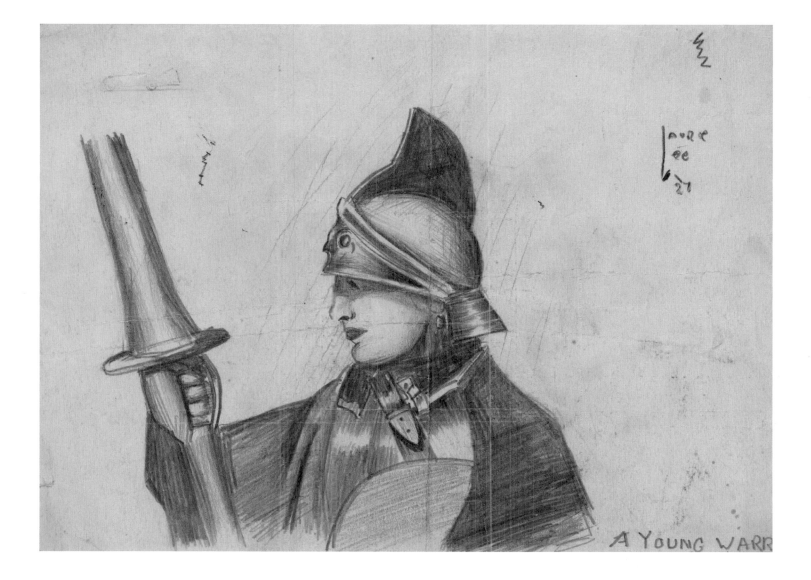

SCHOOL DRAWINGS
c. 1924
Pencil on paper
274 x 184 mm

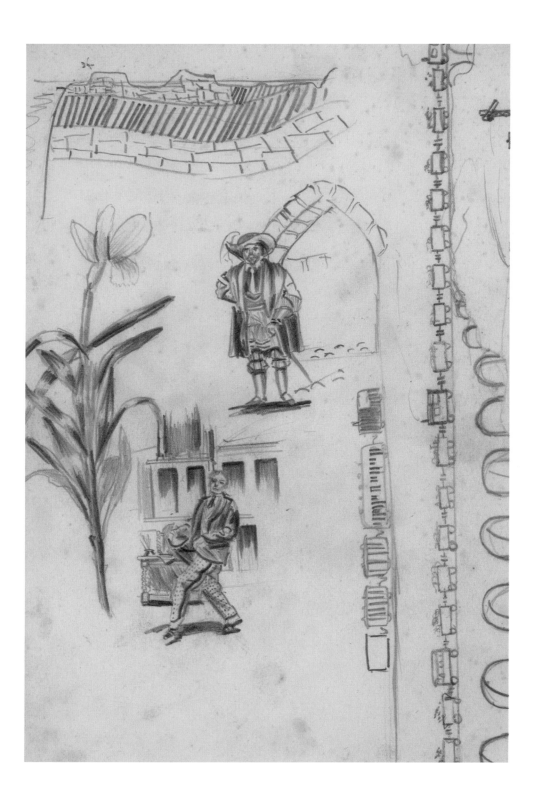

SCHOOL DRAWINGS
c. 1924
Pencil on paper
274 x 184 mm

watch his display. (In summer Mum would sunbathe up there with Lis Frink behind screens they had made from sheets.) Thinking he would try and make up for scaring us rigid, Dad sought to entertain us again. With a giant Catherine wheel in his teeth and holding two Roman flares in his bare hands, he set fire to himself. We watched in terror as this human firework walked around in a circle with sparks flying like some Pagan ceremonial effigy. Entertaining as this was, it was no comfort and I think we didn't talk to him for a month after that.

One way he could always redeem himself and make us laugh again would be to fill up balloons with water and drop them out of the top floor window in front of passers by. Of course, he would probably be arrested for that these days.

Favourite haunts included Finches and the Queen's Elm in the Fulham Road and the nearby Chelsea Arts Club in Old Church Street - all in walking distance from the flat in Elm Park Gardens. Bryan Wharton, the war correspondent and award winning photographer, was a dear friend to all of us and Dad called him the White Knight – a pseudonym which I thought suited him deeply. He told me that in the Chelsea Arts Club, when

noise coming from the cupboard. We froze while a ghostly figure emerged in white with a stocking on its head. Dad had snuck into the flat without us knowing and had hidden in my bedroom cupboard - for what must have been at least an hour - waiting for me to go to bed.

We didn't speak to him for a week, or at least until bonfire night. Here Dad would put any fire-starter to shame. We were able to get onto the roof of the flat, which was thickly tarred, sticky and had no barriers, to

Laurie Lee

HARLEQUIN
c. 1939
Pencil on paper
383 x 280 mm

ANGRY WOMAN
c. 1936
Lino print on paper
418 x 268 mm

WOMAN WITH BRACELETS
c. 1941
Ink on paper
254 x 202 mm

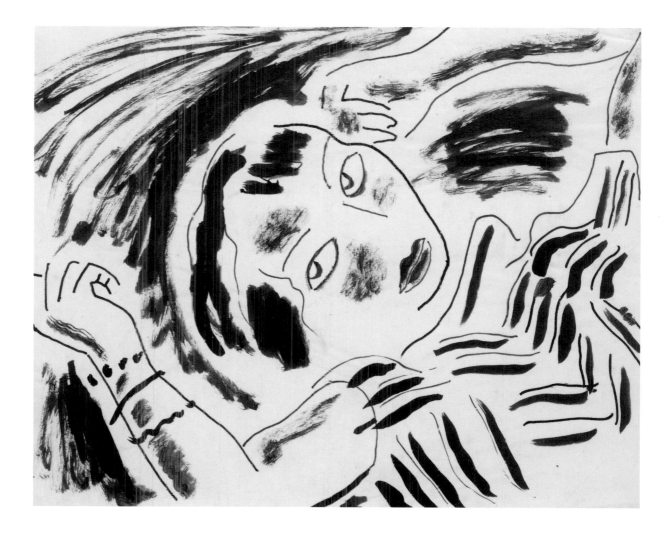

RIVER TARN
c. 1969
Photograph

RIVER TARN
c. 1969
Photograph

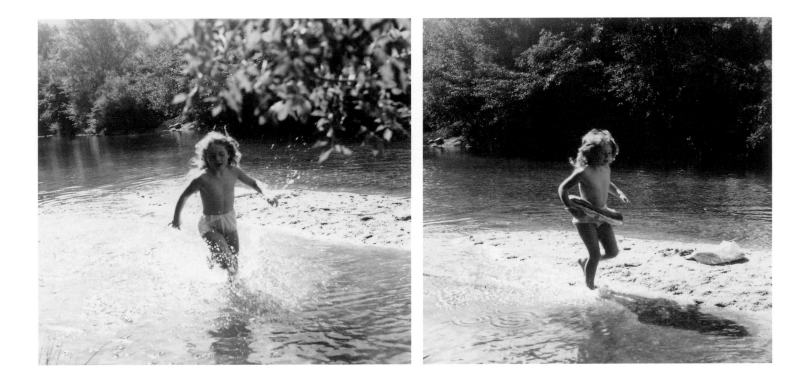

Dad was getting on in years, they set up a 'Laurie watch'. A group of friends would take it in turns to secretly follow Dad when leaving the club to make sure he would get home safely. Dad too had his fair share of supporting his friends and frequently soothed the brows of the tormented who had got themselves into some kind of state or were tired and emotional.

Back in number 49, other artists there were Ian Stevenson, Jane and Geff Hoare and Dame Elisabeth Frink. They all became dear friends and Mum became Godmother to their children, Tessana Hoare and Lin Jammet, Lis's son by her first husband, Michel. Lis moved to France before I came along and I have some vivid early memories of going to visit them in her farmhouse in the Cevennes. I remember her being perpetually covered in dust and always chipping away at something even if it was an onion.

Mum tells me when Lis was pregnant she would secure the waistband of her black jeans which she mostly lived in with a piece of string to accommodate her expansion. By the time I joined them in France, Lis was now married to her second husband Edward (Ted) Pool.

Lis would occasionally lend us her yellow Renault 4 so that we could disappear for the day down to the river *Tarn*. To get there was a trial, as Mum would have to drive over a narrow bridge which was exactly the width of the car with no side barriers to prevent one veering off. This river which we crossed was flanked by a lovely little sandy beach where Mum made me an intricate sandcastle with its own working chimney which actually let the smoke out from its tiny fire made from tiny pieces of driftwood. Within this river was a small pool of still water, which was just out of my depth.

This is where Dad taught me to swim. I always thought it was yet another ingenious idea of his to gradually let the air out of my rubber ring, while encouraging me to swim a little more out of my depth. Eventually, the ring deflated and I could swim; joining in with the rest of them. The swimming pool wasn't a grand affair: a deep, concrete, plunge pool painted blue with no shallow end, which rather unnerved me. What was even more unnerving was when I arrived to find Ted removing his artificial leg before he was to dive in. Later I discovered that Ted had lost his foot soon after D-Day and he had been awarded the Military Cross.

I Can't Stay Long, a collection of his travel pieces and essays, was published by Andre Deutsch in 1975. It sold well but not on the scale of his autobiographical works. Reading this book enlightened me in many ways and introduced me to a side of Dad that I hadn't appreciated in such a way before. As ever, he would describe ordinary events by distilling his experiences, almost like turning them into spirits. Even as he was putting this book together he seems to have been drawn to a time when he was a carefree young man. He says of his essays:

"What strikes me most strongly about a lot of them now is their confident enthusiasm and unabashed celebration of the obvious." *I Can't Stay Long*

I discovered a level of compassion and observation that deeply touched me. In particular his essay about the terrible disaster at Aberfan, *The Village That Lost Its Children*. I think this essay profoundly influenced me to learn to hear the pain of loss. He described the affect on the bereaved mothers:

"Meanwhile, the lost mothers of Aberfan continue to live out their half-lives, wandering aimless round their empty houses, haunting their doorsteps, sitting dull-eyed in cafés, waiting for the afternoon climb to

SCHOOL DRAWINGS
c. 1925
Pencil on paper
274 x 184 mm

V1 AND BUILDING
c. 1944
Ink on paper
240 x 272 mm

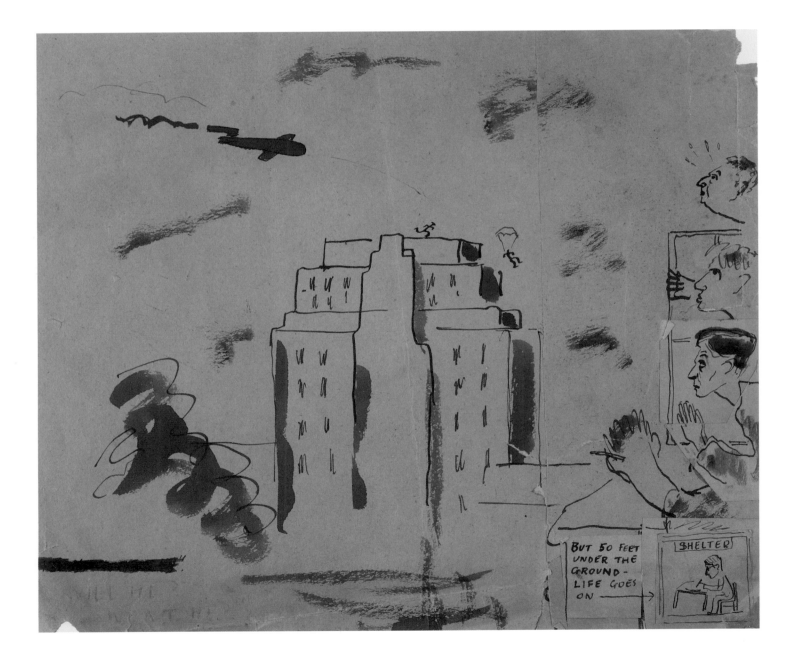

FESTIVAL OF BRITAIN
c. 1951
Ink on paper
272 x 240 mm

the graves. It is as though part of the chambers of their minds had collapsed inside them. One wonders if they will ever be whole again."
I Can't Stay Long

I could also describe at great length the jewels hidden in that most underrated book – the emotions, pictures and great humour. He recalls his maiden trip on Concorde - although he abhorred flying. To add to his misery, a force eight gale was blowing. "In the distance, as far from the sky, I could hear a thin ghostly wail. Perhaps the flight would be cancelled? My spirits rose. 'Oh no, he'll fly,' said the girl.'"

He describes miserably: "Typical airfield, typical cold slap of upper Cotswolds, typical petulant winter's day – water-tanks on stilts, huts roofed with bent iron, wet concrete, birds flying backwards." *I Can't Stay Long*

Dad was very perceptive of people. He could read someone in an instant and often spent much time listening to tales of relationship breakdowns, or of unrequited loves, or he would seductively tell people their fortunes by holding their thumbs. This mostly pertained to women, of course. He would always encourage people to

be themselves and would always find something within them to celebrate. Conversely, he suffered no fools and hated pomposity. He wrote four essays on the human condition in *I Can't Stay Long*: Love, Appetite, Charm and Paradise.

Key

A. Family Tree.

B. Deeply laid plots, hatching.

C. Man taking down a cloud for the night.

D. Uneducated aeroplane dropping aitches.

E. Two birds with one stone. (Isn't that killing?"

F. Me learning to swim on dry land because Hydrophobia swimming in sand. I don't like water.

G. Secret aeroplane trap. The aeroplanes look down the hole, think the ground is further away than it is, and crash, see?

H. I don't know what this is, but I had to have something to lean the ladder against.

STUDENT WITH GUITAR
c. 1970
Pencil on paper
360 x 269 mm

In the late 1970s, Mum and I spent increasingly more time in Slad. Mum had become a churchwarden and then worked almost full time for the Nuclear Freeze Campaign writing to bishops and MPs. Having just left college, I spent a lot of time playing the piano and guitar composing music for the band I was singing for at the time. Realising I wasn't going to be the rock star I had fantasised about, I became committed to working with children with learning difficulties and homeless families. This partly influenced my later career as a psychotherapist, which I embarked upon after Dad had died. I only wish he could have seen me in my mortar board and gown; he would have rather liked the ceremony of it all. I hope he would have been pleased.

Laurie Lee

Self-Portrait with Guitar
c. 1952
Pencil on paper
408 x 254 mm

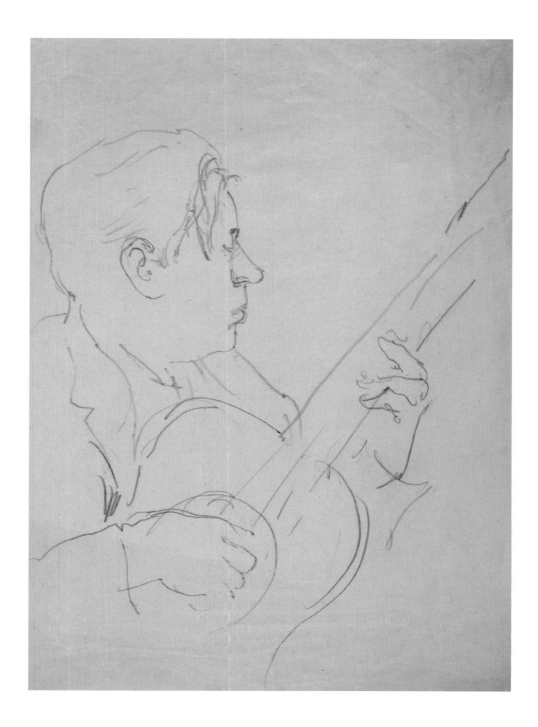

STUDY FOR RECLINING NUDE WITH TREES
c. 1937
Gouache and ink on paper
350 x 510 mm

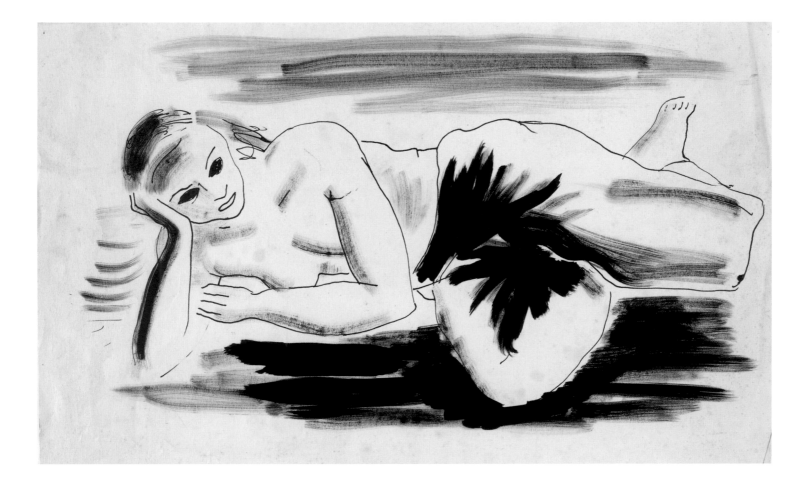

RECLINING NUDE WITH TREES
c. 1937
Gouache on paper
350 x 510 mm

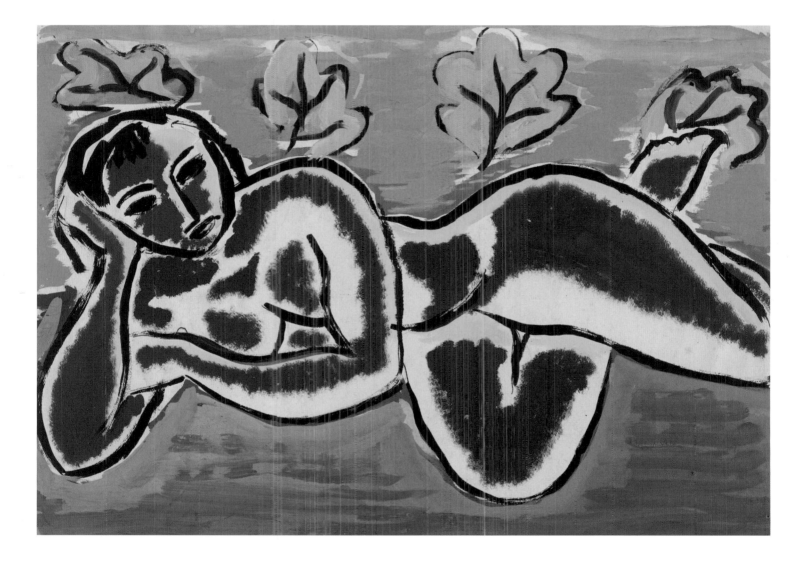

LAURIE'S MOTHER, ANNIE LEE
1942
Pencil on paper
398 x 308 mm

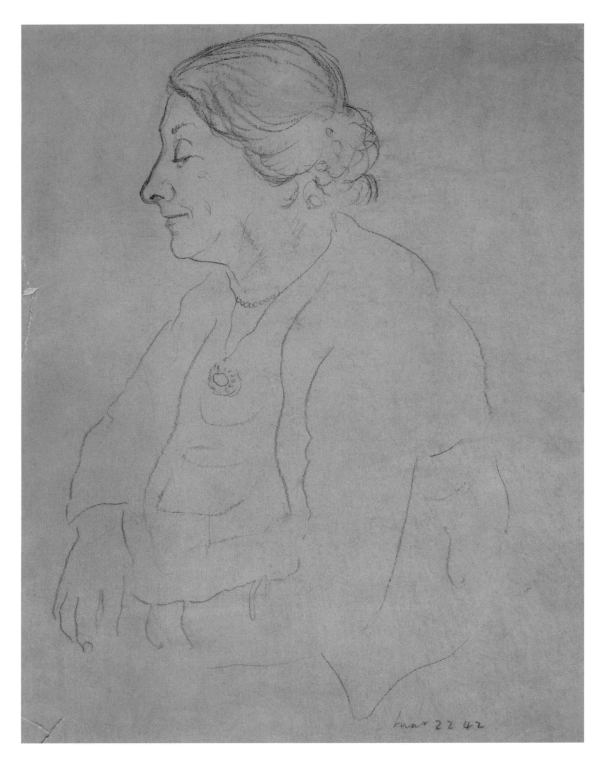

Laurie Lee

LAURIE'S MOTHER, ANNIE LEE
1936
Pencil on paper
236 x 172 mm

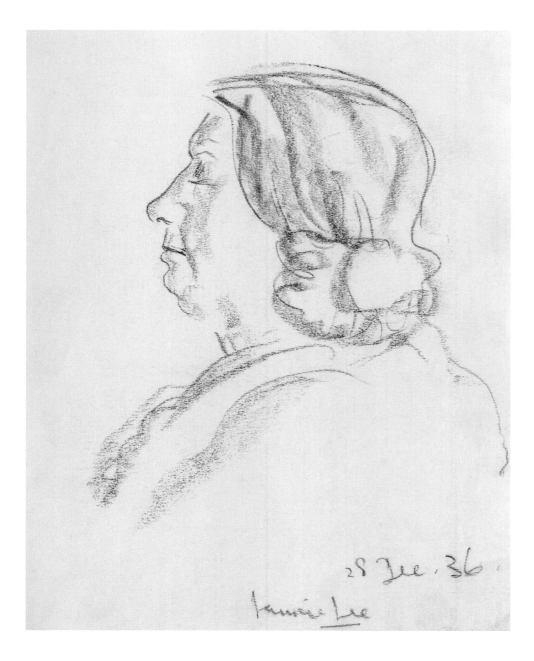

During the 1980s Laurie continued to be adored. Even I was surprised when he celebrated his 70th birthday in 1984, as Dad never discussed his age, telling me that his "mother was rather vague and had probably got the date wrong anyway." He looked younger than his years and was always elegantly dressed.

In 1984, twenty years after *The Firstborn*, Dad was encouraged to prepare a new book of his photographs of Mum and me. The book was to be called *Two Women*. It was to be about 'the two women who have occupied most of my late adult life, enclosing it in a double embrace, like bookends'. He had an artist's touch with the camera, and the photographs were judged to be exquisite.

Unfortunately, he did not tell us about the book and, sadly, he didn't get the thanks or recognition from us that he was hoping for. At the time, Mum and I were embarrassed by our private worlds becoming so public and our cosy family photographs being available for all to see. The text, however, was as romantic and poetic as ever, describing beautifully how he had fallen in love with Mum and his feelings when she gave birth to me – and his observations of my personality as I was growing into a woman. Although, at the time, I had wished the book had never become public, I now treasure its words and understand why Dad published this book. I came to realise how deeply he feared losing control of himself and also feared losing the two women he loved the most. We knew he loved us.

CAR IN DITCH
1940
Ink on paper
252 x 202 mm

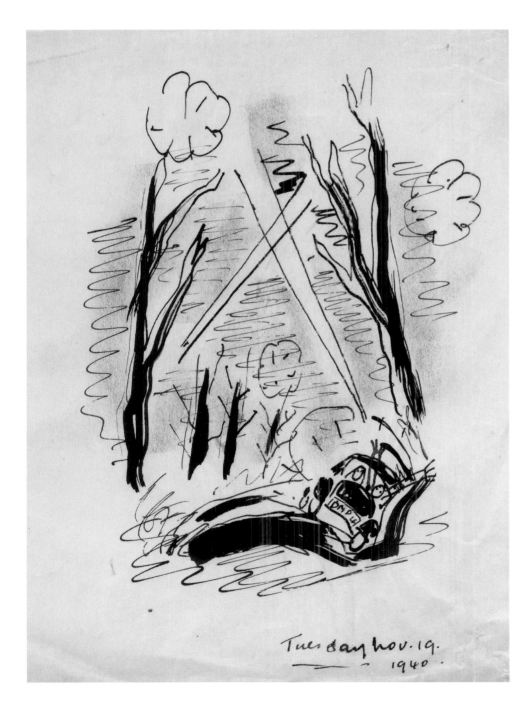

SCHOOL DRAWING
c. 1924
Pencil on paper
274 x 184 mm

MAP OF SLAD
c. 1925
Gouache on paper
377 x 278 mm

In his last years he had become a national institution and a national treasure. *Cider with Rosie* ensured a continuing interest in Laurie himself, especially after it became a favourite school text book. Everybody wanted to know who Rosie was, but as Laurie explained dozens of times: 'There were six or seven girls in the village school she could have been. *Cider with Edna?* or *Cider with Doreen?* It could have been any of those girls, but Rosie sounded right.'

He would take such trouble to answer letters. School children would ask for his advice on how to write poetry or what it takes to write an interesting essay. In his archive there are piles of letters from fans. He would sometimes become ill with his efforts to respond personally. He never wanted a secretary and as he grew older and his eyesight and handwriting were failing, he would sometimes dictate letters to Mum for her to type for him.

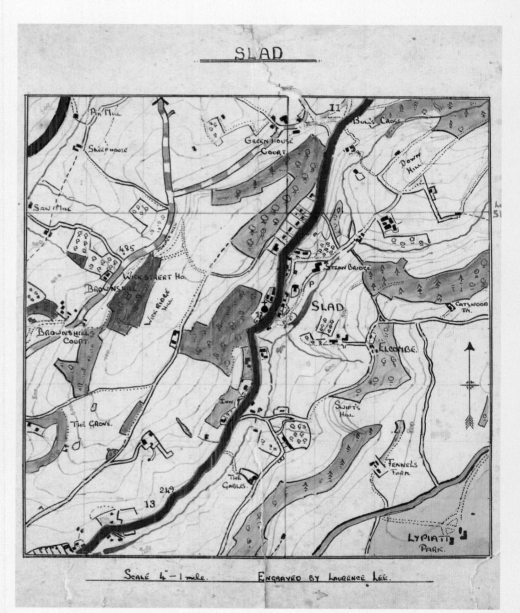

SCHOOL DRAWINGS
1925
Pencil on paper
274 x 184 mm

SCHOOL DRAWINGS
c. 1924
Pencil on paper
274 x 184 mm

Although he couldn't always be available, he wanted to give what he could. I found the following piece in the back of an old diary. He wrote:

"Surprisingly little of a child's work is merely pretty or sentimental, but there is often a truth outlined in good – a house squatting in the rain like a casket of jewels, a single flower like a fragment of sun, or the stark face of a school friend staring out of the dark, sometimes brutal or frank in its recognition of a fellow animal, but never superior, ingratiating or sly."

People still tell me now how he had such a passion for his community. When the new post office opened

NUDE FIGURE
c. 1937
Charcoal and chalk on paper
331 x 202 mm

in Stroud, I was told he brought flowers for the staff. He fought for his landscape, he fought for the disenchanted and fought for the war-torn and hungry in whichever form they came.

He lived between the secular and the spiritual. He played mystic and philosopher well and people would feel better about themselves after seeing him. For such a private man, he made many public appearances and in his archive are countless press cuttings and advertisements for them.

LANDSCAPE WITH TREES
Date unkown
Lino print on paper
384 x 284 mm

KILL THE FASCISTS
1938
Ink on paper
254 x 205 mm

PORTRAIT OF A MAN WITH CIGARETTE
1935
Pencil on paper
258 x 200 mm

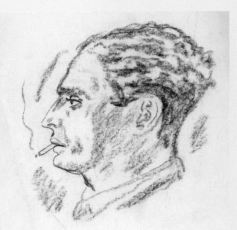

Because he was superstitious, Dad was also private about what he was writing. He never forced his books upon me and the only time he discussed his plans with me was just six years before he died. *A Moment of War* was going to be published in 1991. During one of our many profound conversations he told me of his time in Spain during the Civil War. He felt he owed the Spanish for their hospitality and wanted this book to be a tribute to them. He told me there was much he had left out and would tell me more later. He never did find the time.

FIELD OF AUTUMN

Slow moves the acid breath of noon
over the copper-coated hill,
slow from the wild crab's bearded breast
the palsied apples fall.

Like coloured smoke the day hangs fire,
taking the village without sound;
the vulture-headed sun lies low
chained to the violet ground.

The horse upon the rocky height
rolls all the valley in his eye,
but dares not raise his foot or move
his shoulder from the fly.

The sheep, snail-backed against the wall,
lifts her blind face but does not know
the cry her blackened tongue gives forth
is the first bleat of snow.

Each bird and stone, each roof and well,
feels the gold foot of autumn pass;
each spider binds with glittering snare
the splintered bones of grass.

Slow moves the hour that sucks our life,
slow drops the late wasp from the pear,
the rose tree's thread of scent draws thin –
and snaps upon the air.

SELF-PORTRAIT
c. 1936
Pencil on paper
477 x 320 mm

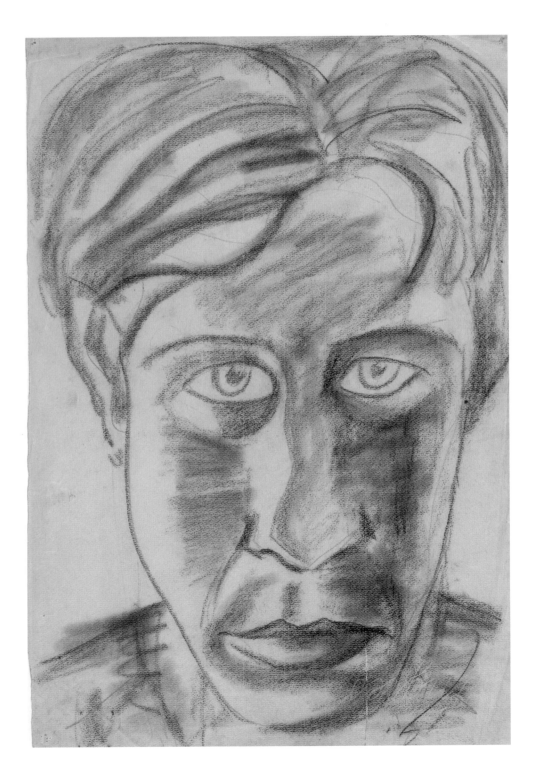

Laurie Lee

Dad was not so kind to himself
though. His need for perfection could
make him difficult to live with but
this need certainly contributed to
his exquisite use of words and how
he could make them dance with
colour. When I think of his words
I can see some of them bundled up
closely together, invoking warmth
and security and others are in stark
contrast invoking the intensity of polar
opposites – still needing each other
for impact. His poetry waxed and
waned like his lunar moods – from
the seductive to the melancholy but
always richly delivered. His words and
drawings were kept in an emotional
envelope – some reactionary and some
cathartic.

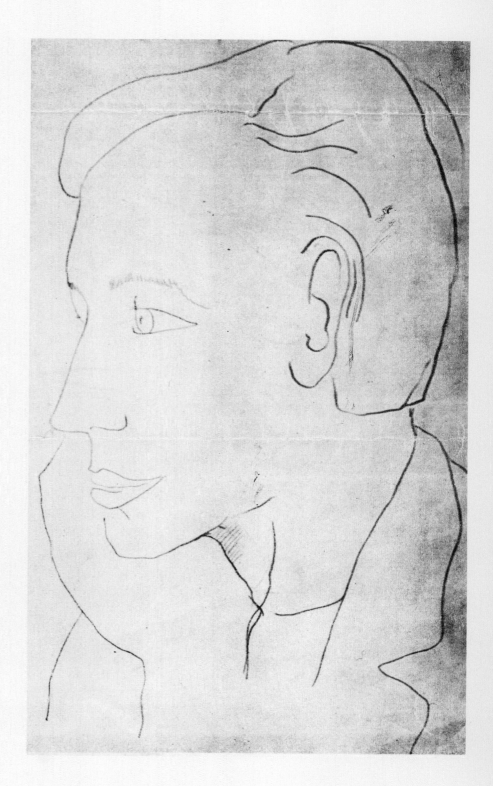

PREGNANT WOMAN WITH CACTUS PLANT
c. 1936
Lino print on paper
354 x 320 mm

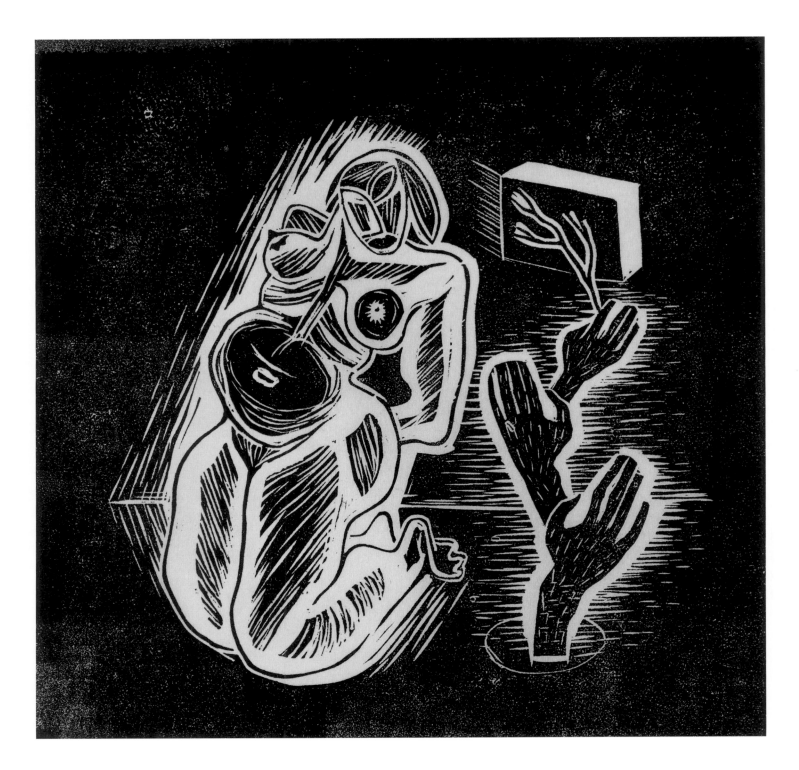

COCO DE MER
c. 1936
Ink on paper
377 x 281 mm

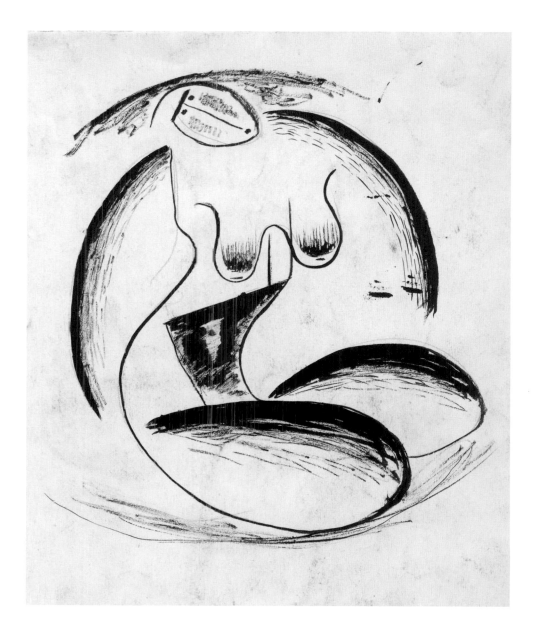

One-Eyed Cat
Date unknown
Ink on paper
267 x 166 mm

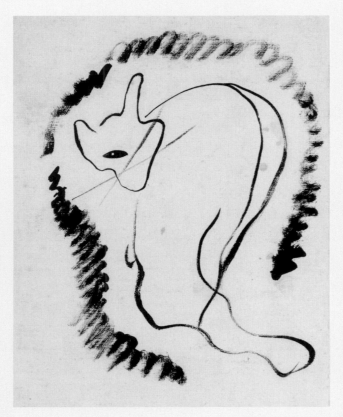

That grey art folder was all forgotten until a few years after Dad had died. Mum came across it under his bed, wedged between two old suitcases upon which my cat Walter had both slept and died. I both felt miserable after losing my eighteen year old feline friend but elated that Walter had led me to discover the folder. Mum then told me that years ago Dad wanted me to have it. So he had thought about it after all.

Throughout his life Laurie admired artists, particularly Miro, Picasso and Gaugin and often said he wished he had become a painter. I had wondered if he had ever wanted his art to be seen and then I found a quotation from him amongst his papers:

"I always wanted to be a painter – a drawer – but that sounds funny. Best of all, after music, I like to draw. But I always liked to feel wanted and no-one ever said to me, 'We'd like some more of your paintings', – so this made me write. If they'd wanted my paintings, I'd be an artist now, earning lots of money, surrounded by beautiful girls."

Laurie Lee

Frith Wood, Slad
c. 1929
Pencil on paper
255 x 273 mm

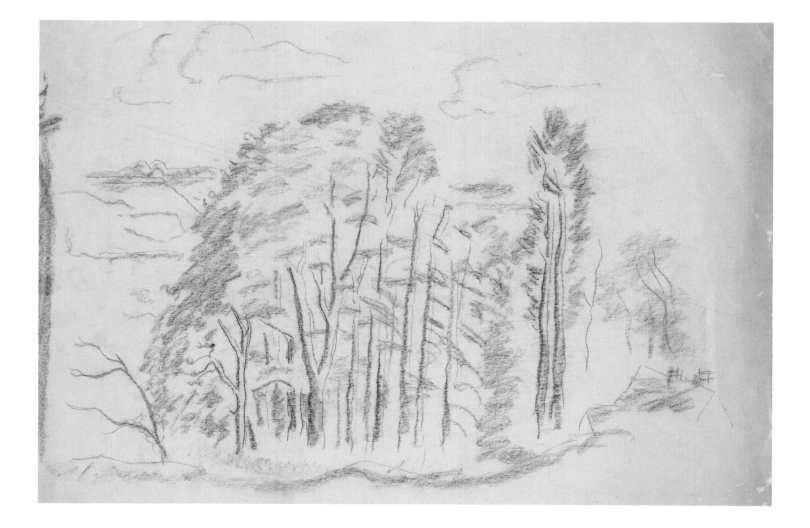

WOMAN AND CHILD WALKING
1936
Pencil on paper
164 x 133 mm

FIGURE IN LANDSCAPE
c. 1939
Ink and collage on paper
278 x 384 mm

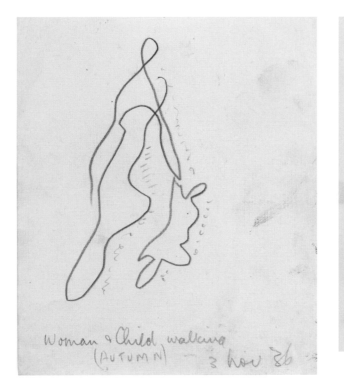

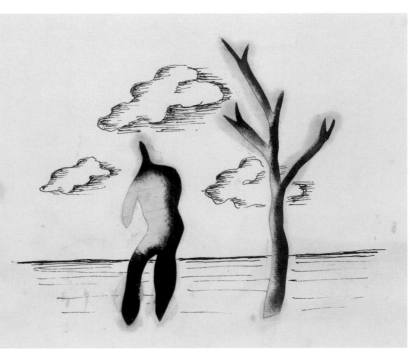

Laurie Lee

ORANGE AND BLUE ABSTRACT
c. 1937
Mixed media on paper
290 x 205 mm

ABSTRACT FIGURE, WALKING
c. 1936
Ink and gouache on paper
502 x 326 mm

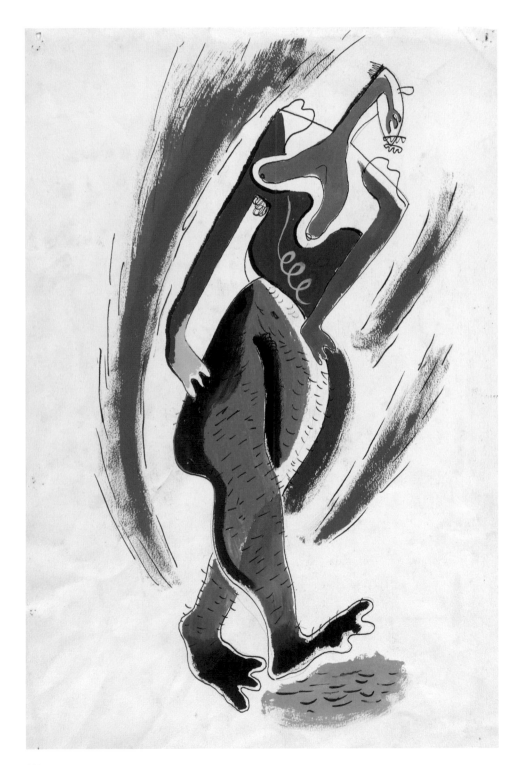

WOMAN READING
1938
Ink on paper
280 x 370 mm

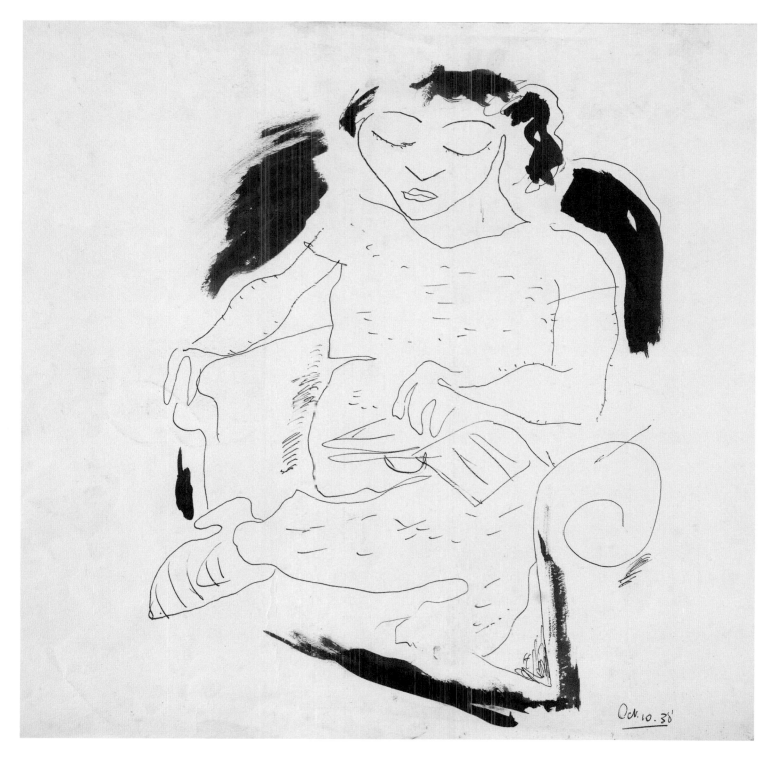

KATHY SLEEPING
c. 1970
Ink on paper
349 x 241 mm

JESSY
c. 1972
Pencil and ink on paper
127 x 101 mm

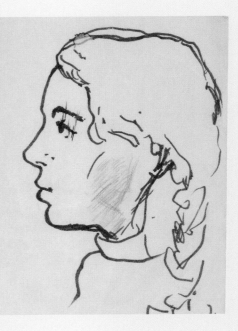

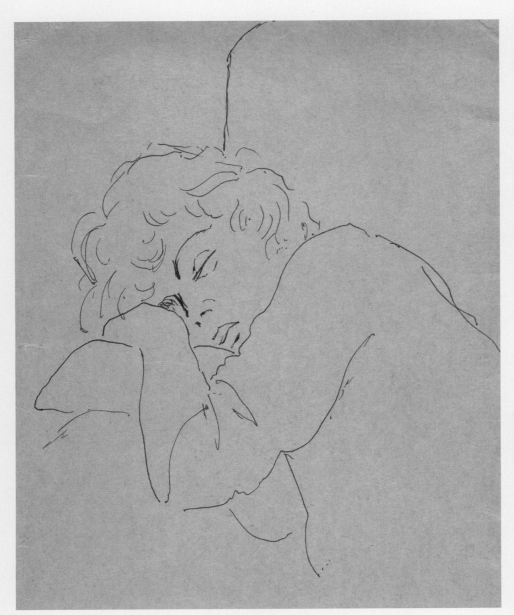

I fear that Mum and I never thanked him for *Two Women* and *The Firstborn*. Being about the same age Dad was when I was born, I now have a deeper understanding of the more complicated episodes in our lives and can celebrate these two books – which for the most part of my life, I hid away from. I hope this book is in some way paying homage to Laurie Lee, my Dad.

The sky turned black, two rainbows appeared and he died with us both at home in Slad on 13th May 1997.

SELF PORTRAIT
c. 1936
Ink and pencil on paper
276 x 214 mm

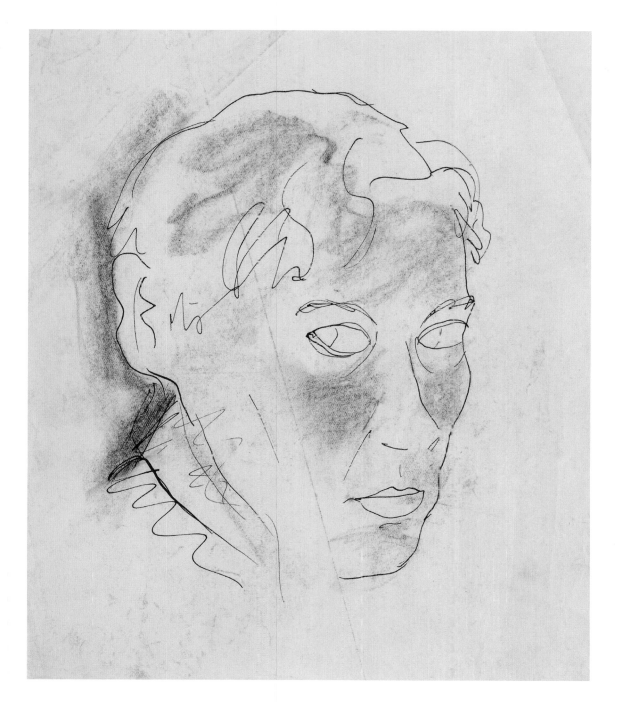

APRIL RISE

If ever I saw blessing in the air
 I see it now in this still early day
Where lemon-green the vaporous morning drips
 Wet sunlight on the powder of my eye.

Blown bubble-film of blue, the sky wraps round
 Weeds of warm light whose every root and rod
Splutters with soapy green, and all the world
 Sweats with the bead of summer in its bud.

If ever I heard blessing it is there
 Where birds in trees that shoals and shadows are
Splash with their hidden wings and drops of sound
 Break on my ears their crests of throbbing air.

Pure in the haze the emerald sun dilates,
 The lips of sparrows milk the mossy stones,
While white as water by the lake a girl
 Swims her green hand among the gathered swans.

Now, as the almond burns its smoking wick,
 Dropping small flames to light the candled grass;
Now, as my low blood scales its second chance,
 If ever world were blessèd, now it is.